GHOSTS
OF THE
NORTH EAST

GHOSTS
OF THE
NORTH EAST

ROB KIRKUP

AMBERLEY

First published 2025

Amberley Publishing
The Hill, Stroud
Gloucestershire, GL5 4EP

www.amberley-books.com

Copyright © Rob Kirkup, 2025

The right of Rob Kirkup to be identified as
the Author of this work has been asserted in
accordance with the Copyrights, Designs and
Patents Act 1988.

ISBN 978 1 3981 2167 6 (print)
ISBN 978 1 3981 2168 3 (ebook)

All rights reserved. No part of this book may be
reprinted or reproduced or utilised in any form
or by any electronic, mechanical or other means,
now known or hereafter invented, including
photocopying and recording, or in any information
storage or retrieval system, without the permission
in writing from the Publishers.

British Library Cataloguing in Publication Data.
A catalogue record for this book is available from the
British Library.

Typeset by Simon and Sons ITES Services Pvt. Ltd.,
Chennai, India.
Printed in Great Britain.

Appointed GPSR EU Representative: Easy Access
System Europe Oü, 16879218
Address: Mustamäe tee 50, 10621, Tallinn, Estonia
Contact Details: gpsr.requests@easproject.com,
+358 40 500 3575

Contents

Introduction	6
1. Northumberland	**8**
The Holy Island of Lindisfarne	8
Flodden Field	14
The Dirty Bottles	19
Winter's Gibbet	20
The Schooner Hotel	23
Chillingham Castle	28
2. Tyne and Wear	**37**
Souter Lighthouse	37
Hylton Castle	38
The Castle Keep	41
Marsden Grotto	48
The Angel View Inn	51
Gibside	52
3. County Durham	**54**
Bowes Castle	54
Barnard Castle	55
Cauldron Snout	58
Durham Castle	60
Crook Hall	63
Lumley Castle	64
The North of England Lead Mining Museum	68
Beamish Hall	71
4. Teesside	**77**
Dorman Museum	77
Seaton Hotel	80
Camerons Brewery	81
Middlesbrough's Central Library	82
Acklam Hall	83
The Swatters Carr	86
Wynyard Woodland Park	88
Preston Hall Museum	89
About the Author	94

Introduction

The north-east of England is a region rich in history and natural beauty, and it has a strong sense of pride in its local heritage and identity. From the rugged coastline to the rolling hills and vibrant cities, each part of the region we will explore throughout these pages offers something as unique as it is terrifying. Allow me to guide you through my native North East, stopping off in Northumberland, Tyne and Wear, County Durham, and Teesside, and I will tell you of some of the chilling phantoms said to stalk this region.

Northumberland
A land of remote, wild moorlands, beautiful, unspoiled coastlines, and the most castles of any county in England. It's a place where history and nature intertwine, from the imposing fortress of Chillingham Castle to the serene beauty of the Northumberland National Park. Hadrian's Wall, a reminder of the Roman Empire's reach, cuts through the landscape, and the region's remote villages and market towns preserve the charm of times past.

Tyne and Wear
The vibrant heart of the North East, known for its bustling cities, thriving cultural scene, and iconic landmarks. Newcastle upon Tyne, with its seven famous bridges over the River Tyne, is a hub of energy and creativity. The neighbouring city of Sunderland offers a blend of industrial heritage and scenic coastline. Together, these cities embody the spirit of the North East: resilient, and welcoming to anyone and everyone. From the galleries and music venues to the historic streets of Tynemouth, Tyne and Wear offers something for everyone, and it's no surprise that it attracts people to come and visit all year round.

County Durham
A place where history comes alive amid stunning landscapes. The city of Durham, with its majestic cathedral and winding river, feels like stepping into a medieval painting. Beyond the city, the county is home to picturesque villages, lush woodlands, and the expansive Durham Dales. Mining heritage runs deep here, shaping both the land and the communities. County Durham offers a blend of tranquillity and history, where ancient traditions still hold sway in the modern world.

Teesside

With its industrial roots and proud communities, Teesside is a region in transformation. Known for its steelworks, shipyards, and chemical industries, Teesside has long been a centre of innovation and hard work. Today, the area is embracing change, with new developments in green energy and technology. The industrial landscape is complemented by natural beauty, with the stunning cliffs of Saltburn and the wide-open beaches of Redcar offering a stark contrast to the urban centres. Teesside is a place where resilience and reinvention define its future.

As we investigate the North East I will introduce you to a plethora of locations believed to be home to ghosts and ghouls, including castles, hotels, pubs, and even a haunted waterfall. Read on if you dare.

All photographs taken by the author, unless otherwise stated.

Souter Lighthouse.

I

Northumberland

The Holy Island of Lindisfarne

Holy Island is a special place, and it must be to attract 650,000 visitors to it each year, especially given only 160 people call the island home. Many come to see the castle and the priory, to enjoy the walks across the small island, which is only half a mile north to south, and a mile east to west, and the novelty of having to cross to the island over a causeway which floods twice a day. Others, however, come because Holy Island was the birthplace of Christianity in Northumberland – hence its name. Although the island was called Lindisfarne, its Celtic name, until the eleventh century which is still commonly used by locals.

In 634 Oswald, King of Northumbria, invited Christian missionaries from Iona to convert his people from their pagan traditions. This was the birth of Christianity in the region, and saw Lindisfarne emerge as a pivotal centre of Christianity. Even though the initial missionary, Corman, failed and was sent back, he was replaced by Aidan and a small group of Irish monks and they were successful in evangelising Northumberland. Aidan became the first of sixteen bishops at Lindisfarne, the most renowned being Cuthbert. In 685, King Egfrid asked Cuthbert to become Bishop of Lindisfarne. Though reluctant, Cuthbert agreed but foretold his own death within two years and retreated to his cabin on Inner Farne, an island where he had lived before becoming bishop. He died on 20 March 687.

Cuthbert's body was taken from Inner Farne to Lindisfarne, placed in a stone coffin, and buried at St Peter's Church. His fame drew many pilgrims who claimed to be healed at his grave, leading the monks to declare him a saint. In 698, his body was exhumed, placed in a wooden coffin with valuable relics, and his sainthood was proclaimed.

On 8 June 793, this peaceful, holiest of islands suffered a savage surprise attack from the Vikings. This raid sent shockwaves through English Christendom and marked the beginning of the Viking age in Europe.

In 875, due to bloody Viking raids, the monks fled Lindisfarne, taking with them St Cuthbert's coffin, St Aidan's bones, the Lindisfarne Gospels, and other treasures and relics. They wandered for eight years before settling in Chester-le-Street in 883, eventually moving to Durham in 995. St Cuthbert was finally laid to rest in Durham Cathedral, where his grave, marked with 'Cuthbertus', and the remnants of his wooden coffin and relics are displayed today.

Lindisfarne was abandoned for nearly two centuries, leading to the decay of the church and monastery. In 1082, monks from Durham returned and established Lindisfarne Priory.

St Cuthbert's Chapel on Inner Farne.

St Cuthbert.

St Cuthbert's Island.

They lived modestly under the rule of a prior until the Dissolution of the Monasteries in 1537, which disbanded monastic communities and rendered the priory obsolete.

Due to its strategic position, Lindisfarne was vulnerable to attacks from Scots and Norsemen, leading to the construction of Lindisfarne Castle in 1550 on Beblowe Hill using stone from the disused priory.

In 1903, Edward Hudson from *Country Life* magazine visited the island and was dismayed by the castle's dilapidated state. He enlisted the help of renowned architect Sir Edwin Lutyens to restore and convert the castle into a residence. In 1944, the castle was given to the National Trust, and they have maintained it since.

Holy Island's most famous ghostly resident is also the most famous character in the island's history, St Cuthbert. He is seen in secluded areas such as the priory and along the shore. His favourite haunt is believed to be St Cuthbert's Island, marked by a large wooden cross and accessible only at low tide. Over the last century, numerous sightings of spectral monks have been reported crossing the Pilgrim's Way, an ancient series of stepping stones used in the eleventh century. Some believe these are the spirits of monks from their pilgrimages or those who perished during Viking raids. In the 1930s, two fishermen reported seeing twelve ghostly monks walking above the water at high tide.

Lindisfarne Priory.

One of Lindisfarne's oldest legends from the 1100s speaks of a monstrous sea creature, the Kraken, which was said to devour those caught on the causeway by the incoming tide. Bodies of the drowned were often found with missing limbs and eyes, believed to be the work of this fearsome beast. Sightings of a large brown monster in the North Sea between the Northumberland coast and Holy Island further fuelled this legend.

A haunted structure on the island that may also have connections to the drownings that occurred all those centuries ago is the disused coastguard station. It's been claimed that a phantom stares out of a window roughly 15 feet from ground level. It has an almost skeletal face, partially covered in shrivelled leathery green skin. The spectre has no eyeballs, just holes where the eyes once were. Some believe it to be the ghost of an invader struck down by lightening after murdering a monk. In his 1992 book *Ghost Trails of Northumberland* (Casdec Ltd) author Clive Kristen offers an alternative explanation.

He writes that it's a reflection of a face outside of the station, as opposed to inside it. Over the centuries there have been thousands of shipwrecks around the islands off the coast of Northumberland, and at one time it was almost a common occurrence to find a partially decomposed, partially eaten, corpse wash up on the shore along Northumberland.

The disused lifeguard station.

The coast guard would be alerted on these occasions and one young coastguard stationed on Holy Island became so distressed retrieving one particularly grisly body, that had clearly been in the water a long time, that he started having horrific recurring nightmares. He woke up one night screaming. He got up from his bed and ran to the relative safety of his coast guard station. However, when he reached the station he saw in the window, by the light of the moon, the face of the man he had pulled from the sea.

Could it be that the tortured mind of this young man has somehow left the gruesome reflection forever into the glass?

The ruined priory is said to be haunted by a ghostly monk dressed unusually in white. While he is never visible to the naked eye, he often appears in photographs taken of the archway at the priory's entrance. Visitors have reported hearing faint chanting and whispers, as if ancient monks are still at prayer.

Lindisfarne Castle, despite its relatively short and uneventful history, is home to at least one ghostly presence. Keys have been seen turning in locks by themselves, and doors have been known to open and slam shut without any breeze. Additionally, there is a legend of a large white dog, known as a shuck, that appears to anyone wandering near the castle late at night, only to retreat into the shadows.

Lindisfarne Castle.

Flodden Field

There's a belief that ghosts linger at locations where people have died in traumatic circumstances. It's no surprise, then, that battlefields worldwide are considered haunted due to the sheer number of deaths that occurred there. Northumberland is no exception, and the monument at Flodden Field, erected in 1910, commemorates the greatest loss of life in any battle on English soil, the Battle of Flodden Field.

A little over 500 years ago, in this field, which will have been largely the same then as it is today, as many as 14,000 were slain here in the space of just three hours. With such a huge loss of life in horrific circumstances it's no surprise that there have been reports of strange happenings at the site of the battle ever since.

The Battle of Flodden Field, also known as the Battle of Branxton, took place on 9 September 1513 between an invading Scots army under the command of King James IV and an English army led by Thomas Howard. It was both the last medieval and first modern British battle. The 'last medieval' because the longbow played an active part for the final time; the 'first modern' because it began, as you'll soon hear, with an exchange of artillery fire.

On 22 August a Scottish army of 80,000 men crossed the Tweed at Coldstream and entered England. On their way to the battle, the Scottish army had laid siege to, and burned, the castles of Norham, Ark, and Etal. The Scots then conquered Ford Castle which became their headquarters. King James' army decided to spend a few days here, with many of his men deciding to head back to Scotland with stolen livestock. Lady Ford fell for the charm of the King and occupied most of his time while at the castle.

While the Scottish were at Ford, the English were heading north in readiness for the battle. Thomas Howard, the Earl of Surrey, set up his HQ at Pontefract Castle at the beginning of August. By the end of August, he was at Newcastle-upon-Tyne alongside his army. On 3 September they arrived at Alnwick Castle where the earl was joined by the Lord Admiral, who had brought over 1,000 men from his fleet to join the English army which now numbered around 25,000 in all.

Eventually the fateful day arrived. The weather was terrible: it was misty and the rain fell heavily. The two armies now stood almost a mile apart separated by a stretch of boggy ground known as Branxton Moor. The Scots were positioned at the top of Branxton Hill looking down at the English positioned below them at the foot of the hill. The two sides were evenly numbered, but there was no doubt that the Scottish were at a huge advantage given their position. Their artillery was also of a higher calibre than the guns available to the English.

The battle began at 4 p.m. that day, when both sides opened fire with their artillery. The English got the better of this exchange, with the Scottish gunmen looking cumbersome and inaccurate. King James identified a weakness in the English right wing, a section of men from Lancashire and Cheshire under Edmund Howard who looked unorganised. James ordered the Scottish left wing to attack and they charged down the hill. The majority of Edmund's men fled, leaving the brave soldiers who remained to be quickly cut down. Lord Darce and some English borderers took up the fight with the Scottish left. They quickly received added support and fought to keep the Scots at bay.

Flodden Monument, the spot where the battle turned in the favour of the English.

The bottom of the hill.

The English right was very close to collapse and was only saved when Thomas Howard ordered a cavalry charge the Scottish left. This persuaded the Scottish left to fall back, after which they decided they had played their part in the battle and fled to safety.

King James was excited by the scene unfolding before him and was keen to get involved in the battle. He led the Scottish centre charge down the hill towards the English centre, being led by the Earl of Surrey. The English centre stood their ground as the Scots neared. But the Scottish lost their momentum as they reached the bottom of the hill as found themselves crossing marshy, boggy ground. The English seized the initiative and engaged them in combat.

The central column of Scots was mostly armed with 18-foot-long pikes, somewhat bulky and heavy weapons, usually meant for use against cavalry. This proved to be ineffective when faced with infantry armed with billhooks who simply chopped the heads off the pikes turning them into ineffective wooden poles. The decision by King James to leave the advantageous position at the top of the hill was to prove the turning point of the battle.

The English strategy was far superior and after much manoeuvring the main body of the remnants of the Scottish army was now surrounded. Gradually the English hacked them down until only a handful of spearmen remained defending their king. They were quickly dispatched leaving only a few desperate nobles left standing, before they too joined the thousands of corpses on Branxton Moor.

Over 10,000 Scots lost their life at Flodden during the battle, estimated fatalities of the English range from just 400 to 4,000. Among the Scottish killed that day was King James IV himself, the last British monarch to be killed in battle. He was joined among the Scottish dead by nine earls, fourteen Lords of Parliament, the Archbishop of St Andrews, as well as dozens of chieftains, nobles and knights.

The following morning Border Reivers looted the dead, taking valuables and weapons. The bodies of the dead were thrown into two large pits. Most of the bodies were thrown into a deep pit at the site of the battle and the remaining thrown in a pit in the churchyard in Branxton.

Branxton Church.

Thomas Dacre, 2nd Baron Dacre of Gilsland discovered the body of James IV on the battlefield. He later wrote that the Scots 'love me worst of any Englishman living, by reason that I fande the body of the King of Scots'. The chronicle writer John Stow gave a location for the king's death as Pipard's Hill. The location of this is now unknown, but historians suggest it may have been the small hill on Branxton Ridge overlooking Branxton Church. It seems likely we'll never know, and the location of James' death is lost to time.

Dacre took the body to Berwick-upon-Tweed, where according to Hall's Chronicle, it was viewed by the captured Scottish courtiers William Scott and John Forman who acknowledged it was the king's. The body was embalmed, then taken from York to Newcastle upon Tyne, a city that James had promised to capture before Michaelmas, then the body was taken to Sheen Priory near London.

James's banner, sword and armour, were taken to the shrine of St Cuthbert at Durham Cathedral. Much of the armour of the Scottish casualties was sold on the field, and 350 suits of armour were taken to Nottingham Castle. A list of horses taken at the field runs to twenty-four pages.

There are a number of legends that surround the body of the fallen king. It is widely believed that King James IV's body was buried at Lanercost Priory, but there may be a much more gruesome reality. It has been suggested that his body was disembowelled and sent to London. His body was kept in the Monastery of Sheen, then moved into

a storage room. Years later it was discovered by workmen who cut off the head and used it for a macabre plaything. It was passed from one English noble to another for years, until it was finally buried in an anonymous grave.

There's even a theory that the king didn't die at the battle. These suggestions began the month after the battle was lost as a Scottish merchant at Tournai in October claimed to have spoken with him.

Robert Lindsay of Pitscottie, a Scottish chronicler and author of *The Historie and Chronicles of Scotland, 1436–1565*, the first history of Scotland to be composed in Scots rather than Latin, recorded that the king escaped Flodden Field, made it back north of the border but was killed somewhere between Duns and Kelso.

Similarly, John Lesley, a Scottish Roman Catholic bishop and historian, wrote sixty years after the battle that the body taken to England was actually 'my lord Bonhard'. And he too writes that James was seen in Kelso after the battle, but wasn't killed, instead going on pilgrimage in far nations.

George Buchanan, a Scottish historian and humanist scholar, also wrote that James IV had escaped the field, leaving his Squire of Attendance, Alexander Elphinstone, 1st Lord Elphinstone to fight on, and that it was Elphinstone's body that the English mistook for the king, due to him being clothed in royal insignia and his stature being similar to that of James.

A paranormal belief crept in when it was suggested that the king had been warned against invading England by supernatural powers. While he was praying in St Michael's Kirk at Linlithgow in West Lothian, Scotland, on the eve of battle, the church doors swung open and a young man walked towards him. The king looked on in astonishment at what the man was wearing. He had a blue robe which seemed to move all on its own, sandals, and a scarlet sash around his waist. His blond hair flowed behind him, and the king was convinced he was in the presence of an angel.

The angel, who the chroniclers of the time can't decide upon, with some saying this was St John and others saying St Michael, marched straight past the king's entourage. Mere inches away, he looked the king in the eye and told him that he had been sent by none other than the Virgin Mary herself to command him not to go into battle, for if he did the Scots would lose, and many of their number, including the king himself, would die. The mother of Jesus forbade the king from crossing the border into England. He must stay in Scotland. Not only this but he should be wary of taking the counsel of women. This appears to be in reference to Mary Tudor, Queen of France, who had personally asked James to invade England, even giving him a ring from her own finger as a token of their allegiance.

The figure turned and walked out of the church, the message delivered. The king was shaken and told many people of what he had been told in the church, but as we know only too well, he paid it no heed. The Scots marched to Flodden Hill.

Paolo Giovio was an Italian physician, historian, and biographer, and in 1549 he wrote an account that claimed that three other bad omens preceded the battle. When James was in council at the camp at Flodden Edge, a hare ran out of his tent and when his knights attempted to stop the beast, it evaded their weapons. Mice were discovered to

The A697, where ghostly soldiers are still seen.

have gnawed away the strings and buckle of the king's helmet; and on the morning of the battle his tent was speckled with dew, and the dew was the colour of blood.

Ever since the battle there have been frequent reports of the ghostly sounds of the battle coming from the field, the clash of swords, the screams and groans of the dying soldiers. These sounds are still heard by the locals to this very day, especially in the dead of night.

The A697 nearby has been the location of sightings of phantom soldiers crossing the road. In the 1700s two brothers swore that they saw the entire battle being re-fought. When questioned about it afterwards they could describe precisely what happened, they could describe what people looked like and what was on their banners.

The Dirty Bottles

Alnwick is one of the most attractive towns in Northumberland, if not all of England. You can sense the history as you explore the cobbled roads, and narrow, medieval streets. The main street is accessed via an enormous fifteenth-century tower gate. Alnwick is best known for its castle which dates back to 1096 and is known the world over as Hogwarts from the Harry Potter movies. There are the beautiful Alnwick Garden, one of the world's most extraordinary contemporary gardens. Barter Books is situated within Alnwick's Victorian railway station and is one of Britain's biggest second-hand book shops.

The Dirty Bottles.

Then there is the Dirty Bottles. Situated on Narrowgate, this public house has been serving drinks to the people of Alnwick for well over 200 years, and it is named for a legend dating from the early 1800s. The innkeeper was positioning bottles in the window when he dropped down dead for seemingly no rational reason. His widow declared that if anyone should touch those bottles, they too would suffer the same fate as her beloved husband. The bottles were sealed in the window between two panes of glass, where they remain today covered in dust and cobwebs.

Winter's Gibbet

Winter's Gibbet, also known as Elsdon Gibbet, is a monument to murder.

Margaret Crozier resided at Raw Pele Tower, situated 2 miles north of Elsdon. Known for selling cloth and other goods from her home, she was a beloved elderly lady in the community. One day, she received a visit from two young sisters who were seeking customers. They were struck by the valuable items scattered around Margaret's home, which they realised could fetch a good price if stolen.

The sisters befriended a traveller named William Winter who had recently arrived in Elsdon. Winter, a lifelong criminal with only six months of freedom in the past eighteen years, was intrigued when they described Margaret and her valuable possessions. Being in a remote location, they speculated that if they killed her, her body might not be

discovered right away, allowing them ample time to escape. Recognising the opportunity, Winter agreed to the plan, and they made a pact.

On the stormy night of 29 August 1791, Winter found the perfect opportunity he had been waiting for. The rain poured down and the wind howled, ensuring few would venture out. Using the inclement weather as cover, he approached Margaret's home at Raw Pele Tower. The sisters waited nearby as Winter knocked on the door. Margaret, seeing a weary traveller in need of shelter, kindly invited him inside despite the late hour and the harsh conditions. Taking advantage of her hospitality, Winter viciously attacked the defenceless old lady, striking her and fracturing her left temple before fatally cutting her throat. He signalled to the sisters, who then entered the home and together they plundered it, taking all the cloth and valuables they could carry.

Instead of fleeing, they chose to remain in Elsdon, a decision that would lead to their undoing. The trio sat on a hillside, casually eating fruit when Robert Hindmarsh, an eleven-year-old shepherd, spotted them and quietly approached. Observing Winter's distinctive knife for peeling apples, Hindmarsh immediately recognised it as belonging to Margaret Crozier, who had been recently murdered. He also took note of the peculiar nail-like marks on the murderer's shoe soles.

Her body had been discovered two days later when a regular customer, Barbara Drummond, arrived at the shop and saw thread lying on the ground outside the closed doors. This was unusual so Barbara sought out neighbours and told them of what she had found. Two of them, Elizabeth Jackson and William Dodds, returned with her and they found her body.

Hindmarsh notified the police, and Winter and the sisters were quickly caught thanks mainly to the tracks left by Winter's shoes in the soft mud after the heavy rainfall.

On 10 August 1792, all three were executed at the Westgate in Newcastle. The executioner, William Gardner, himself a convicted criminal condemned for sheep stealing, agreed to carry out the execution in exchange for a reduced sentence: transportation to New South Wales. Witnesses reported that Winter ascended the scaffold with apparent composure. However, his execution was protracted and gruesome; it took nearly half an hour for him to succumb, during which he writhed and convulsed at the end of the rope. Spectators were shocked by the disfigurement of his face after death; his eyeballs protruded from their sockets and he had nearly bitten through his tongue, which had turned blue.

The bodies of the Clark sisters were sent to a local surgery for dissection. However, due to strong public sentiment regarding the crime, it was decided that William Winter's body should be returned to Elsdon and displayed in a gibbet cage for all to see. His corpse was transported on a cart and the gibbet was erected on Whiskershields Common, located 3 miles south of Elsdon. Over time, birds picked at his lifeless body, pecking out his eyeballs and consuming his decaying flesh. Insects and maggots soon infested the remains, and wild animals fed on any flesh that fell from the cage. Eventually, only his bones remained. Traditionally, the bones would have been buried at the gibbet site, but some of Winter's bones were taken by morbid souvenir collectors. The remaining bones were scattered within 100 meters of the gibbet, and Winter's skull was sent to Mr Darnell in Newcastle. The current whereabouts of Mr Darnell and the skull are unknown.

Winter's Gibbet in 2008 when a replica head hung from the monument.

The current Winter's Gibbet, not on its original site, was reconstructed in 1867 under the directive of Sir Walter Trevelyan of Wallington. Initially featuring a full wooden body, the body was later removed due to it being used for target practice, leaving only a carved head hanging there today. The head has been stolen multiple times over the years, and in 1998 the entire gibbet mysteriously disappeared, though it was fortunately recovered shortly thereafter.

Winter's Gibbet, 2024.

William Winter's ghost is often sighted late at night near the replica gibbet site, which is unusual considering he did not die there, nor was the original gibbet located at this spot. Interestingly, the most frequent sightings of Winter's spirit occur near a cattle grid close to Harwood Forest, approximately 100 meters from the replica gibbet. It is believed that some of his remains might have been scattered in this area. Witnesses who claim to have encountered the ghost of William Winter describe a figure covered in rusty chains, with decaying greenish flesh and empty eye sockets. More commonly, people report seeing dark human-like shapes crossing the road before disappearing into thin air.

In the autumn of 1931 a man by the name of Tom Ebley wrote:

I was taken by the chill of the wind and the way the clouds acted like a blind to the moonlight. The head rustled in its mounts and the flickering shadows played upon it. I had heard the tales of Winter's walking and now it seemed the putrid green flesh, rusted chains, and a knife that drips blood – gripped firmly in the skeletal fingers of the right hand – were no phantasms of the mind.
I heard a sound like groaning in the woods behind followed by a distinctive shuffling of feet. I dared not look in that direction but began to move away. The steps followed my course and I began to run. I reached my motorbike and started her up. As I moved off hastily I could hear a rattling of chains and a wild bark of laughter. I will not return to that place again.

As alluded to in Ebley's account, many have experienced strange sounds coming from the nearby woodland of Harwood Forest, leading some to suggest that perhaps some of Winter's scattered bones could have ended up here. Groaning sounds, followed by a distinctive shuffling of feet, is reported. This is often accompanied by a noise that sounds like a rattling of chains.

Margaret Crozier's ghost is considered much gentler. It is said that she continues to haunt Raw Pele Tower, now part of Raw Pele Farm, with sightings of her spirit frequently walking between the farm buildings after nightfall. Additionally, she is believed to be responsible for doors and windows unexpectedly swinging open.

The Schooner Hotel

The Schooner Hotel, with a history spanning 400 years, has witnessed murder, suicide, and massacre. Unsurprisingly, the Poltergeist Society has twice named it the Most Haunted Hotel in Great Britain. The hotel is reputed to house over sixty individual ghosts, with more than 3,000 sightings recorded in the past decade.

The seventeenth-century inn boasts a rich and troubled history. Notable figures such as Charles Dickens and King George III are said to have visited the Schooner.

The Schooner Hotel is located in Alnmouth, a small village in Northumberland at the mouth of the River Aln. By 1208, Alnmouth had become a key seaport, primarily dealing in grain. However, the village faced significant setbacks: Scottish raiders attacked in 1336 and the Black Death struck in 1348, nearly wiping out the population.

Above and left: The Schooner Hotel.

The Schooner Hotel, built in the seventeenth century, emerged when Alnmouth was a bustling trading port. Smuggling was rampant and as the village's only inn, the Schooner, quickly became a favoured spot for smugglers. A secret tunnel in the cellar led to the nearby beach, allowing smugglers to move undetected under the cover of darkness to conduct their illicit activities.

In 1742, the Schooner began brewing its own ale, which was well-received by the locals. A cask of this ale was gifted to Parson Smyth, who was touched by the gesture and decided to try it. Tragically, as he was connecting the tap, it shot out and struck him on the head, killing him instantly. The tap was returned to the Schooner, and superstitious locals believed that if it was ever used again, the Parson's blood would flow from it. Parson Smyth's ghost is said to haunt the ground floor of the Schooner Hotel to this day, becoming its most famous resident.

The De-Vere family, a married couple with two children from France, checked into the inn and were shown to their room, which is now room 28. Tragically, they had no idea these would be their final moments. A smuggler sneaked up behind them, struck them on the head with a heavy object, and dragged their unconscious bodies into the room. All four of them had their throats cut.

After stealing anything of value, their bodies were removed through the smugglers' tunnel under the cover of darkness and thrown overboard from a small boat.

The wing where this massacre occurred is believed to be the most haunted area of the Schooner Hotel. Dark shadows are regularly seen in rooms 28, 29, and 30. Visitors often report feeling sick or dizzy in these rooms but feel fine as soon as they leave.

Room 28.

The spirits of a young boy and girl have been seen and heard playing in room 28 at night. Staff members have reported hearing whispers and screams from the room when they are known to be unoccupied.

The corridor outside these rooms retains its original flooring from 400 years ago. The creaky floorboards frequently lead visitors to hear footsteps, often reported by terrified guests standing alone in the corridor.

Visitors to room 30 have reported a drastic drop in temperature and finding the door inexplicably locked when they tried to leave. To their horror, a dark shadowy figure has appeared in the room with them. It is said that a man committed suicide in room 30, and it is possible that his spirit is the one haunting it to this day.

Room 4 is another location where a murder occurred. A man was choked to death in his sleep by an unknown assailant. Visitors staying in the room have reported hearing sounds at night resembling someone struggling to breathe. Some have even felt hands tightening around their throats, as if they were being strangled.

A particularly violent storm hit Northumberland on Christmas Eve 1806, and a woman sat at the fireside in the busy Schooner Inn. She was anxiously awaiting the return of her husband, who was a fisherman out at sea in the storm. Her six-year-old daughter slept on her lap.

Suddenly, the door burst open, letting in wind and rain, followed by a breathless man who had raced to the Schooner with dreadful news: a boat had capsized in the storm, and everyone onboard had purely perished. This was the boat the woman's husband had been on.

The woman fainted at the news, striking her head on the fireplace as she fell. Her sleeping daughter tumbled into the roaring fire, awakening with screams as the flames engulfed her. Men drinking in the bar rushed to bravely pull her from the fire, but she was badly burned and died in agony within minutes.

When the mother regained consciousness, the first thing she saw was the charred body of her little girl. She was inconsolable. Within a matter of minutes, she'd lost everything that was dear to her, her husband and her daughter were both dead. In a fit of despair, she ran into the stormy night, never to be seen in Alnmouth again.

The spirit of the young girl, affectionately nicknamed Lizzie, is said to haunt the Chase Bar. She is a friendly spirit, often seen running around the tables before vanishing near the fireplace.

The corridor outside rooms 15 to 19 is said to be haunted by the ghost of a small boy. Though little is known about him, it is believed that he rides a tricycle up and down the corridor at night. Unexplained scratches have been found on the doors, thought to be caused by the boy's tricycle bumping into them as he plays.

Rooms 16 and 17 seem to share an unknown spirit as in both rooms it has been reported that guests have awoken in the middle of the night and a dark man-shaped shadow has been stood at the foot of the bed watching them sleep. As soon as a light is turned on in panic the figure vanishes. A separate spirit also appears to have a connection, specifically, with these two rooms as he's been stood outside of the room, pounding on the doors, then vanishing.

There are spirits in the Schooner Hotel that seem to roam freely throughout its rooms and corridors. Guests have woken during the night to find a man in military uniform

The hotel's bar.

staring at them, a phenomenon reported in multiple rooms over the years. A spectral chambermaid is frequently seen in the corridors and staircases of the hotel, particularly on the stairs leading to rooms 31 and 32. Additionally, there have been numerous sightings of white mists swiftly moving through the corridors, and lights turning on and off in empty rooms.

Chillingham Castle

Chillingham Castle began life as Chillingham Tower in the twelfth century, established by De Grey a nobleman from Normandy. Unlike many of the castles in Northumberland, Chillingham Castle was not fortified until the middle of the fourteenth century, when it was granted the royal licence to crenulate in 1344. The existing structure was strengthened and a stone wall was built to protect it further, which saw the tower transformed to a castle.

The castle was attacked many, many times in the centuries that followed during the border wars, being so close to the border with Scotland.

Over the years the castle was rebuilt and strengthened further and in 1590 the main entrance of the castle was moved to the north wall, where it is still found today. In the eighteenth and nineteenth centuries further changes were made by the Grey family. This is when the central staircase was built from the courtyard up to the entrance of the great hall.

The castle was abandoned in 1933 due to the huge cost of maintaining it, so the Grey family packed up and moved into a house close to the village of Chillingham. Chillingham Castle was left without a purpose. It was no longer a home, except to the rats and wildlife that moved in, as the once great castle decayed, as plaster fell from the walls and the stonework began to crumble.

Chillingham Castle.

The entrance to the great hall from the courtyard.

It was left empty for almost fifty years, until the Chillingham Castle estate was bought in 1982 by Sir Humphry Wakefield and the honourable Lady Wakefield took over the estate and the enormous task of restoring the castle to its former glory. Lady Katherine Wakefield is a direct descendant of Lady Mary Grey, ensuring that the castle is once again occupied by the Grey family, as it has been since it was initially built over 800 years ago.

Chillingham Castle has seen more than its fair share of bloodshed. A man by the name of John Sage ensured that this was the case. There's no evidence that Sage ever existed, but in recent years he has become synonymous with Chillingham Castle's dark past. John Sage was the torturer at Chillingham during the border wars. Before Sage was the castle's torturer, he was one of King Edward I's best men on the battlefield. He had worked his way up to the rank of lieutenant but was injured one day in battle when a Scot forced a spear through his leg. Sage could no longer fight for his country, he dragged his injured leg behind him, earning him the nickname of Dragfoot. Sage loved fighting for England, and hated the Scots, so asked the king to allow him to continue in some capacity. He was handed the role of castle torturer at Chillingham.

John Sage revelled in the role, even devising some nightmarish torture devices of his own. Among the most notorious implements of torture and death at his disposal was the iron maiden, a coffin-like structure with spikes designed to pierce the body of the victim. The rack, another brutal instrument, was used to stretch the body, dislocating limbs and

Chillingham Castle's torture chamber.

causing excruciating pain and permanent damage. He utilised a boiling pot, barrels lined with spikes in which prisoners were rolled until their flesh was torn away. There are cages that would have been attached to a prisoners stomach and a starved rat would be put inside and the only way out for the rat was to eat his way out through the victim. These were dark, brutal times, and the pain, suffering, and death dealt out at Chillingham Castle by John Sage is unimaginable. It's been claimed that he held the role for three years, and during that time he would torture upwards of fifty Scots a week.

The only threat to Sage's role as a torturer at Chillingham Castle were times of peace. Not being at war with Scotland meant he was no longer needed, as there was no one to torture. On one such occasion, Edward I ordered the release of all Scottish prisoners. John Sage knew, however, that if he released the Scots they'd head back north of the border and return to seek retribution, whether the two countries were at war or not.

To avoid this fate, Sage devised a sinister plan. He went to nearby English towns and villages, making it known that the Scottish prisoners being held at Chillingham would be freed at a specific time. Despite the war's temporary lull, the hatred held towards their neighbours north of the border was strong as these were the people who'd raided their villages and killed their loved ones. Armed with makeshift weapons, a mob of over 1,000 people gathered near the castle on the designated day, hiding in the trees and bushes that lined the Devil's Walk, the pathway leading to the castle.

When the prisoners were released, their elation soon turned to horror as the local mob, driven by vengeance, ambushed the Scots, brutally killing each and every one of them – men, women, and children – in a savage bloody attack.

Hostilities soon resumed, and Sage returned to what he did best: torturing, maiming, and executing Scottish prisoners. But before long peace was once again restored and he was ordered to release the prisoners; Sage agreed outwardly but had no intention of freeing any of them. He gathered all the young children and confined them in the room known today as the Edward I room. In the castle's courtyard, he lit an enormous bonfire and once the flames were white hot, he methodically threw the older children, men, and women into the flames alive. The stench of burning flesh filled the air, and the screams of agony slowly faded into silence as the last prisoner perished.

Satisfied with his horrific deed, Sage ascended the stone staircase to the Edward I room, where the terrified children, some mere babies, awaited their fate. With a chilling detachment, Sage wielded an axe and slaughtered every one of them, turning the room into a gruesome scene of dismembered bodies and blood.

John Sage's downfall came at the hands of his own torture rack. One night, Sage and his girlfriend, Elizabeth Charlton, were engaging in a sexual encounter on the rack when Sage, attempting to enhance her pleasure, accidentally strangled her to death. This tragedy put Sage in a perilous position, for Elizabeth was the daughter of the powerful leader of the Charlton clan, a notorious group of Border Reivers.

The Edward I Room.

The Charltons were understandably enraged by Elizabeth's death and demanded Sage's execution. They threatened King Edward I, making it clear to him that if Sage were not put to death, they would join forces with the Scots and attack Chillingham Castle. The combined forces of the Scots and the Border Reivers would be a formidable threat, and with the king nearly bankrupt from his campaigns against Scotland, he had little choice but to comply. To avoid a devastating alliance, the order was made by the king, hang John Sage by his neck until dead.

Sage was brought out before a large crowd to face his punishment. He was hanged from a tree along the Devil's Walk, but his suffering did not end there. As he dangled, still alive, the crowd who revered John Sage started taking their grisly souvenirs. They cut off his toes, fingers, testicles, and nose, hacking him to pieces while he still drew breath.

Finally, after his death, Sage's dismembered body was buried at a crossroads, a symbolic act meant to prevent his spirit from finding its way to Heaven, condemning him to wander the path to Hell for all eternity.

The ghost of John Sage is said to wander the castle to this day and many people have said to have seen him along the Devil's Walk or in the Edward I room. Others claim to have heard footsteps followed by the sound of someone dragging something – John Sage dragging his lame leg.

Chillingham Castle boasts an extensive roster of ghostly residents, earning its reputation as perhaps the most haunted castle in Britain, if not the entire world. Every room within the castle's ancient walls harbours its own secrets. The Edward I Room, located in the oldest tower, is renowned as the epicentre of paranormal activity. Named after King Edward I, who visited the castle in 1298, this room is reportedly haunted by numerous spirits, including the vengeful ghost of John Sage.

Visitors often witness the heavy chandelier swinging independently from the ceiling, an unsettling phenomenon that has no apparent cause. The room features a high balcony encircling it, where dark shadows are frequently seen darting swiftly around. These spectral sightings and unexplained occurrences contribute to the room's ominous reputation.

Chillingham Castle houses a grim chamber known as the Oubliette, a small dungeon reserved for prisoners and unwanted guests deemed unworthy of torture, most often children. Those condemned to the Oubliette faced a harrowing fate: their arms and legs were broken before being thrown 20 feet down a narrow pit where they'd be left to die. Death came slowly, either through starvation or infections from their injuries. In their desperation, some prisoners resorted to consuming their own flesh or scavenging from the dead around them.

Peering through the grate that seals the Oubliette, one can still see the skeletal remains of a twelve-year-old girl, the last victim of this dreadful place. The dungeon walls bear haunting evidence of the prisoners' suffering, with marks recording the number of days they endured, or their initials scratched into the stone. Visitors to this eerie room often report a profound sense of despair, with some hearing the wails and groans of those who once languished below, their agonies echoing through the empty pit where so many met their tragic end.

The great hall, built during the Tudor era between two fortified towers, exudes a medieval ambiance. A large tapestry adorns one end of the room, an area known for unusual occurrences such as cold spots and mysterious noises. Figures are frequently seen from the courtyard, passing the windows of the great hall, even when it is unoccupied.

On the balcony known as the minstrels' gallery, people have reported being pushed down the stairs. Many also experience severe headaches and intense nausea while on the balcony, sometimes feeling an overwhelming urge to throw themselves onto the concrete floor below, to their likely death.

The Pink Room, one of the apartments that can be booked within the castle for overnight stays, is the haunt of the Blue Boy, also known as the Radiant Boy, or at least it used to be. For many years his cries and moans were heard around midnight, and the phantom of a tragic young boy bathed in blue light appeared. These paranormal disturbances continued until the 1920s when the body of a young boy was found walled up along with some blue cloth left from his clothing. The bones of his fingers were worn away from where he had been trying in vain to claw his way out. He was given a burial in consecrated ground and his spirit found peace at last, and the moans and sightings ceased. Although those brave enough to spend a night in the Pink Room in more recent years have described seeing a bright blue flash in the room which looks like it could be caused by an electrical fault in the wall. This is the wall where the Blue Boy's remains were found, and it's been confirmed that no electrical cabling runs through that wall. Could it be that the Blue Boy remains here to this very day?

The great hall.

Lady Mary Berkeley is another well-known ghost of the castle. During the reign of Charles II, her husband, Ford, Lord Grey and Earl of Tankerville, abandoned her and their young daughter to run away with her sister, Lady Henrietta. Left alone in the castle with only her child for company, Lady Mary's presence is still felt today. The rustle of her dress and a chilling sensation accompany her as she walks the corridors and stairs, searching for her husband. In the 1920s, a portrait of Lady Mary hung in the nursery, and both family and staff reported seeing her step out of the painting and roam the castle after dark. Although the painting was later sold, her tragic spirit remains.

Another spirit that dates from the castle's past is a soldier who was seen staggering to the main entrance with a full quiver of arrows sticking out of his back. He falls to the ground where he fades away. It is said that if he was seen it would signify that a Scottish attack would surely follow. Understandably he has not been seen in many centuries.

The ghosts of Chillingham Castle aren't confined to the castle itself; the grounds also host their fair share of spirits. A headless gentleman has been seen wandering the Italian garden, often during daylight hours. The lake, once used as a dumping ground for dead prisoners from the castle, is said to be cursed. According to legend, if you put your hand in the water, the souls of the dead will pull you under, never to surface again. Strange noises are heard here late at night, and at least one apparition has been seen walking from the lake.

The castle viewed from the Italian garden.

The lake.

I personally may have encountered one of Chillingham's many ghosts for myself, a spirit I've never seen anyone else speak of.

In December 2005 I led a paranormal investigation at Chillingham Castle, it was a small group comprised of my younger brother, three friends, and myself. At a little after 2:30 a.m. we found ourselves in the chapel, and we'd been joined by Bob, the member of staff on duty throughout our investigation, who had told us when we'd arrived that he was able to speak to the dead that call the castle home.

The five of us were sat in the pews when Bob walked over to a heavy curtain which, at the time, separated the chapel from the minstrels' gallery. 'Eric?' Bob asked as he popped his head around the curtain. He asked for Eric to do his party trick.

We all watched on unsure of what we were looking for. He said that Eric is a twelve- or thirteen-year-old boy, who tragically doesn't understand that he is dead and walks the castle looking for his parents who were killed here. He's a playful young boy who likes to have a bit of fun around the castle and show off. 'Come on Eric,' pleaded Bob.

The curtain was very thick and heavy and was hanging perfectly still. What happened next was without a shadow of a doubt the most inexplicable thing I've ever seen. The curtain suddenly slowly moved as if it was being pushed slowly, and purposely, towards us in the room. It would move a little bit, then stop, and then move a bit further. Then it moved back slowly, bit by bit, as if someone was in control of it.

The chapel.

It hadn't moved a lot, but it was plain for everyone to see. There was a couple of minutes of nothing happening and then it happened again, more forceful and further but still very purposefully. This continued several times, then stopped. Bob asked for Eric to do it again and it did, then stopped just as suddenly. I was amazed, as were we all. I can't think of a single explanation for what I'd just seen except that there was something or someone moving that curtain to show to us that they were there. It also proved that Bob really did seem to be communicating with someone on the other side. Everyone in the castle that night was accounted for when it happened. We were all in that room, seemingly with Eric.

2
Tyne and Wear

Souter Lighthouse

Souter Lighthouse, inaugurated in 1871, was the world's first lighthouse to use electrical alternators. Standing over 75 feet tall, it was designed by James Douglass and constructed by Robert Allison of Whitburn. The lighthouse was erected following the grounding of twenty ships in the area in 1860. Some of these incidents were caused by local residents who would shine lights from the cliffs to mislead ships toward dangerous rocks and cliffs, including Marsden Rock, a massive rock formation detached from the cliff due to erosion. After the ships wrecked, locals would plunder the cargo. Although initially intended for Souter Point, the lighthouse was ultimately built at Lizard Point, a mile to the north. Its light source, weighing 4.5 tons, was set on 1.5 tons of mercury and could be seen up to 26 miles away.

Decommissioned in 1988, Souter Lighthouse is now managed by the National Trust. Visitors can explore the keepers' quarters, the engine room, and the light tower, with the foghorn occasionally sounded during special events.

Souter Lighthouse.

The lighthouse is reputedly haunted by the ghost of a former keeper and another spirit named Bob, a colliery worker who lived and died there in the 1930s. Both are considered harmless, and the staff, who have grown accustomed to their presence, do not find them threatening.

Numerous reports describe objects disappearing only to reappear where they were initially placed, particularly in the engine room where tools often go missing, accompanied by the smell of tobacco smoke. Both staff and visitors have witnessed a mysterious figure walking along the corridor leading to the light tower staircase.

In the kitchen, female staff members have reported being touched by invisible hands, and utensils have been snatched from their grasp.

Hylton Castle

A castle has stood on the site of North Hylton in Sunderland since the eleventh century. Initially constructed of wood, a more permanent fortified manor house replaced it between 1435 and 1447, commissioned by Sir William Hylton. The sole remaining structure today is the gatehouse, an impressive edifice adorned with various stone carvings. These decorations include the arms of the Hylton family, Richard II's white hart emblem, Henry IV's banner, and the Washington family's stars and stripes. Excavations by Channel 4's *Time Team* in 1994, along with existing documentation, revealed that the site once had multiple other buildings to the east of the gatehouse. These likely included facilities such as a kitchen, a hall, private chambers, and barns.

The Hylton family, for whom the area is named, occupied the castle for many generations. Over time, the castle underwent numerous renovations and modifications. In the eighteenth century, Sir John Hylton made significant changes, including redesigning the interior, adding a south wing, installing crenelations on both wings, and replacing the north wing's door with large, fashionable Italianate windows. Sir John was the last of the Hylton line, passing away in 1746. With no male heirs, the estate was inherited by his nephew, Sir Richard Musgrave, who sold it in 1749 to Lady Bowes, widow of Sir George Bowes of Gibside in Gateshead. Whether Lady Bowes resided in the castle remains unclear, but her grandson, John Bowes, 10th Earl of Strathmore and Kinghorne later made improvements. He hired Pietro La Francini, a collaborator of architect Daniel Garrett, who had previously worked on Gibside Banqueting House.

The English writer William Howitt, in his 1842 work *Visits to Remarkable Places* described the rooms at Hylton Castle as having 'stuccoed ceilings, with figures, busts on the walls, and one large scene depicting what appeared to be Venus and Cupid, Apollo playing the fiddle to the gods, Minerva in her helmet, and an old king.' After being unoccupied for some time, the castle was leased in 1812 by Simon Temple, a local businessman who aimed to restore it as a family home. Temple re-roofed the chapel and added battlements to the wings, but financial troubles forced him to abandon the project by 1819. Thomas Wade briefly occupied the castle before it was once again left empty.

By 1840, the castle had become a boarding school, but by 1842 it was deserted, its windows boarded up. A fire broke out in January 1856, causing significant damage. In 1862, the Bowes family sold the property to William Briggs, a local timber merchant

who made drastic changes, aiming to restore the castle to a medieval appearance. His son inherited the castle in 1871 and went on to build the now-demolished St Margaret's Church nearby.

In 1908, the Wearmouth Coal Company acquired the castle, which eventually became the property of the National Coal Board. By the 1940s, Sunderland had expanded rapidly, and the castle found itself surrounded by newly developed housing estates, including one named after it, Hylton Castle. After suffering extensive vandalism, including the theft of lead from its roof, the castle was taken over by the Ministry of Works in 1950 to prevent demolition. The ministry removed all internal partitions and preserved the medieval masonry by replacing the missing lead roof with roofing felt to waterproof the structure.

English Heritage has owned Hylton Castle since 1984. Besides the castle itself, the site also includes the remnants of St Catherine's Chapel, a stone structure dating back to the fifteenth century, built on the foundation of an earlier chapel from 1157. Like the castle, the chapel fell into disrepair during the nineteenth century and was also taken over by the Ministry of Works in 1950. Both the castle and the chapel are designated as Grade I listed buildings and form a Scheduled Ancient Monument.

For many years, Hylton Castle stood unused and unsafe amid Sunderland's housing estates. It was impossible to explore its interior due to safety concerns, leaving people to wonder what mysteries might lie behind its imposing door. In 2017, efforts began to make the castle safe. A £4.2 million project, supported by a partnership between Castle in the

Hylton Castle in 2008, prior to the restoration work.

Community and Sunderland City Council, along with funding from the council and the Heritage Lottery Fund, aimed to transform the site into a heritage and community venue. This initiative followed a long campaign by locals passionate about restoring the castle to its rightful place in the community. Before these efforts, the castle had become a site for graffiti and was best avoided at night due to the presence of local youths engaging in various illicit activities. The castle was opened to the public in 2019.

Hylton Castle is most famously associated with its ghostly inhabitant, the Cauld Lad. In the early 1600s, Sir Robert Hilton, the 13th Baron Hilton, owned the castle. On one particular day, while eagerly awaiting the preparation of his horse for a fox hunt, he discovered that the stable boy, Roger Skelton, had fallen asleep in the hay. In a furious outburst, Sir Robert struck Roger with a pitchfork, killing him instantly. Realising the gravity of his actions, Sir Robert panicked, hid the boy's body under hay, saddled his horse himself, and went out to announce that he had dismissed the boy for sleeping on the job.

Under the cover of night, Sir Robert returned to the stables, wrapped Roger's body in a blanket, and disposed of it in a nearby pond. Despite his efforts to conceal his crime, Sir Robert was tried for Roger Skelton's murder in July 1609. Although he was initially found guilty, he received a full pardon due to the lack of a recovered body. However, it seems that Roger's spirit could not rest, and the castle soon became notorious for paranormal activity.

Witnesses reported hearing eerie wails and cries at night, and the spectral figure of Roger Skelton, often described as naked and shivering, appeared to many, lamenting, 'I'm cauld, I'm cauld.' This ghostly presence became known as the Cauld Lad. Interestingly, the Cauld Lad occasionally displayed helpful tendencies, tidying up the kitchen when the servants left it in disarray. However, if there were no chores for him, he would create chaos by mixing up pantry supplies, overturning chamber pots, and breaking dishes.

These disturbances persisted until 1703 when a pond near the castle was drained, revealing the skeleton of a boy, believed to be Roger Skelton. After a proper Christian burial, the hauntings largely ceased.

Despite the reported peace of the Cauld Lad's spirit, strange events have continued to occur at Hylton Castle. In 1970, a local miner recounted an eerie experience: while returning home from work, he heard a voice call out from the castle grounds. He then saw a dark figure materialize beside him, matching his pace as he ran home in terror. Even after locking himself inside, the miner saw the figure standing motionless outside his door for hours before it vanished.

Reports of unexplained phenomena continued into the late 1970s, when locals observed large lights moving around the top of the castle, despite the absence of upper floors. In the 1980s, residents were awakened by piercing screams emanating from the castle, prompting calls to the police. Officers searched the premises, but the source of the terrifying noise, which abruptly ceased after about an hour, was never found.

During the many decades that the castle was ruined, and inaccessible accounts of unexplained noises and laughter were regularly reported, coming from within the empty building.

Hylton Castle as it stands today.

The nearby St Catherine's Chapel, where many members of the Hilton family are interred, has also been a site of unusual occurrences. Visitors have reported being pelted with stones, even when alone, and sightings of a ghostly nun wandering the chapel have been documented.

The Castle Keep

Around AD 120, the Romans constructed the first bridge spanning the River Tyne, named Pons Aelius after Emperor Hadrian's family name, Aelius. Hadrian was also responsible for commissioning the construction of a wall in AD 122, stretching from Segedunum at Wallsend on the Tyne to the Solway Firth. To safeguard this strategic crossing, the Romans built a fort overlooking the river. By the eighth century, the area evolved into a settlement known as Monkchester. The remnants of the Roman fort became a Christian cemetery and monastery site.

In 1080, Robert Curthose, the eldest son of William the Conqueror, established a 'new castle' in Monkchester, which subsequently became known as Novum Castellum or New Castle. This fortification was a motte-and-bailey structure, erected over the cemetery, disrupting numerous graves beneath its foundations. The castle was surrounded by a clay rampart topped with a wooden palisade and an external ditch.

Newcastle Castle.

Between 1168 and 1178, King Henry I ordered a reconstruction of the castle in stone, costing £1,144 5s 6d. This project included the creation of a rectangular stone keep and the replacement of the wooden bailey with a triangular stone one. During this period, William 'the Lion' of Scotland invaded but was captured and detained within the castle. The construction was interrupted, evidenced by a fifteen-step staircase ending abruptly against a wall on the keep's second floor.

The barbican, a fortified entrance known later as the Black Gate, was added between 1247 and 1250. Patrick Black, a wealthy London merchant, leased it in the 17th century, giving it its name. In 1272, construction began on the town walls, a nearly 2-mile-long, 2-meter-thick structure designed to repel Scottish invaders.

In 1296, William Wallace led a Scottish campaign southward, destroying Corbridge but bypassing heavily fortified Newcastle. The following year, Wallace and Andrew de Moray secured a decisive victory against the English at the Battle of Stirling Bridge. The Scots then advanced southwards but veered off to Carlisle instead of attacking Newcastle. In 1305, Wallace faced a brutal execution in London, with his severed right arm and other body parts displayed on Newcastle's bridge and the castle's walls.

The Black Gate.

In 1323, Andrew de Harcla, 1st Earl of Carlisle was executed for treason, with one of his quarters placed on the castle walls. By 1400, Newcastle had gained status as a town and county, distinct from Northumberland, although the Castle Garth and its lands remained part of Northumberland. The castle's strategic importance waned, and the castle keep became Northumberland's county jail, separate from Newcastle's gaol at Newgate. Criminals exploited this distinction, seeking sanctuary within the castle walls, technically outside Newcastle's jurisdiction.

The conditions in the castle keep's prison were appalling. Overcrowding forced minor offenders, including children, to share cells with murderers, often leading to fatal consequences. The lack of segregation meant women and men were housed together, resulting in numerous assaults on female prisoners. The unsanitary conditions, with rampant disease among the rats and filth, led to hundreds of deaths from illness.

In 1415, a quarter of Harry Hotspur's body, executed for the Percy family's rebellion against Henry IV, was displayed on the castle keep's walls. In 1589, Queen Elizabeth granted local authorities' permission to enter the castle grounds to arrest criminals. By then, the castle keep had been neglected for over two centuries, its structure crumbling, and the roof missing. Prisoners often stood in several inches of water during winter.

In 1593, Edward Waterson attempted to escape Newgate Gaol by burning down his cell door but was caught and executed. His head was displayed on a spike outside the gaol, with his body parts scattered throughout the town. The west curtain wall partially collapsed in 1620, but the castle was partially restored in 1638 as tensions with Scotland rose. The Scots invaded Newcastle in 1640, occupying it for a year before leaving in 1641 after receiving £300,000 from the English government.

During the Civil War in 1644, Royalist Newcastle was besieged by Parliamentarian Scots, who eventually captured the town and held it until 1647. Between 1650 and 1686, fourteen women and one man accused of witchcraft and wizardry were hanged on Newcastle Town Moor after spending their last days in the castle keep's Garrison Room, where shackles are still visible on a central pillar.

The Garrison Room.

In 1685, James II incorporated the Castle Garth into Newcastle, making it subject to the town's bylaws. On 7 December 1733, a local showman advertised a flight from the top of the castle keep, but, losing his nerve, he strapped his wings to a donkey instead. The donkey was pushed off and survived the 100-foot fall, though it landed on a spectator who died.

By the late eighteenth century, the castle had further deteriorated, with houses built within its walls, the chapel in the keep used as a beer cellar and the Black Gate turned into a slum. In 1810, the Newcastle Corporation purchased the Castle Garth ruins for 600 guineas and began restoration. By 1813, the castle keep was restored and opened to the public. Tragically, on 7 May 1812, gunner John Robson died when a cannon he was firing misfired, blowing off his hand and throwing him off the keep's roof.

Between 1847 and 1849, a railway was constructed through the Castle Garth, dividing it. The Society of Antiquaries acquired the remaining castle structures, clearing the area and hiring architect John Dobson for further restoration. During the Second World War, the Garrison Room served as an air-raid shelter and the keep's roof was used as a fire warden's post.

Archaeological excavations began in 1960 and concluded in 1992, revealing evidence of the Roman fort, Anglo-Saxon burials, and even earlier artifacts like flint flakes and a stone axe predating the Roman period by about 700 years.

The chapel.

The great hall.

With a long history of violent deaths and suffering, the castle keep is regarded as one of the most haunted sites in Tyne and Wear, if not the entire country. Among its many ghostly inhabitants, the Poppy Girl is the most famous. Legend says she was Briony, a fifteen-year-old flower seller in late seventeenth-century Newcastle who was imprisoned with condemned male prisoners in a cell off the Garrison Room. She was assaulted and died from her injuries within eight days, and her body continued to be abused posthumously. Briony's spirit is said to haunt the area, with visitors reporting hearing sobbing, screams, and sometimes sensing the smell of flowers, accompanied by overwhelming sadness.

Other paranormal activities include the sound of chanting prayers in the chapel, sightings of a monk in dark robes, and the fragrance of burning incense. The Mezzanine Chamber is known for mysterious lights and shadowy figures, while the great hall has been the site of loud bangs, swirling mists, and temperature drops. Visitors have also reported seeing a tall man in a cloak and top hat walking across the great hall.

The gallery which runs around the top of the great hall.

Marsden Grotto

In 1782, an out of work miner named Jack Bates relocated from Allendale to Marsden in South Shields, seeking employment. Lacking funds for a traditional house, Jack discovered the numerous caves carved into Marsden Bay's limestone cliffs. With the aid of explosives, he enlarged one of these caves to create a suitable dwelling for himself and his wife. This feat earned him the moniker 'the Blaster'. Jack's struggle to find steady work led him to possibly engage in illicit activities, working with the many smugglers who frequented Marsden Bay, using the caves for centuries as hiding spots for their contraband. In 1788, Jack created a set of stone steps from the beach to the cliff top; these steps, known as 'Jack the Blaster's stairs,' still exist today, believed to be the very ones Jack carved over two centuries ago. After Jack passed away in 1792, his widow left their cave home, leaving it vacant.

In 1826, Peter Allan took up residence in the same cave, further expanding it and making it more accessible. During these modifications he unearthed eighteen human skeletons, likely the remains of smugglers who met untimely ends, perhaps due to betrayals among their own ranks. Allan's extensive work transformed the cave into a two-storey establishment with basic amenities, eventually opening it as an inn called the Tam O'Shanter, which was soon renamed Marsden Grotto. The inn became a popular spot

The Marsden Grotto.

Marsden Bay.

for the era's smugglers, with Allan often turning a blind eye to their illegal activities and even assisting in hiding their goods in exchange for their patronage.

Peter Allan's death in 1849 left the inn in the hands of his wife and children, who continued to operate it. The 1850s brought a series of high tides to Marsden Bay, leading to the deaths of several smugglers and causing repeated flooding at the Marsden Grotto, which required costly repairs. A significant rockslide in 1865 caused substantial damage to the inn, prompting the Allan family to vacate the premises in 1874.

Sidney Milnes Hawkes took over the business and made structural and aesthetic improvements. In 1898, Vaux Brewery purchased Marsden Grotto, installing a lift and successfully managing the establishment for over a century before selling it in 1999. Today, the Marsden Grotto remains a popular bar and restaurant.

The Marsden Grotto, known as Europe's only 'cave bar,' is shrouded in mystery, with rumours of undiscovered hidden rooms. It also holds the reputation of being England's most haunted public house, with frequent reports of unexplained noises, such as banging, whispering, and screaming, along with sightings of apparitions.

In the 1840s, a notorious incident occurred when a smuggler sold information to a customs officer. Discovering his betrayal, fellow smugglers confronted him one stormy night on the beach near the Grotto. Fearing for his life, the man attempted to flee but was captured. Despite his pleas, the smugglers beat him severely, breaking his limbs, and forced him into a barrel used for smuggling goods. They sealed the barrel and left

Above and below: The Cave Bar.

it hidden in a cave, where the smuggler died, his cries echoing for days. The barrel was never found, and it is believed that his remains still lie within the caves of Marsden Bay. Legend has it that his ghost can be heard screaming on stormy nights.

Years later, a customs officer infiltrated the Marsden Grotto, befriending a regular smuggler customer who unknowingly revealed details of his operations. Realising the officer's true identity, a violent altercation ensued, resulting in the smuggler's death. Peter Allan, in a macabre gesture, took the dead man's tankard, nailed it to the wall, and declared that anyone who drank from it would be cursed. He also warned that if the tankard were ever removed, the smuggler's spirit would haunt the Grotto forever.

The original tankard has since disappeared, replaced by a replica. This disappearance has fuelled the belief in the curse, suggesting that the smuggler's restless spirit still haunts the Grotto, manifesting in the unexplained phenomena reported there regularly.

The Angel View Inn

Originally constructed as a farmhouse and stables, the Angel View Inn now serves as a twenty-seven-room hotel, complete with a restaurant, conference facilities, and a banquet hall. The inn, which offers a view of the iconic *Angel of the North*, retains its original stonework as a testament to its past.

Legend has it that a tragic accident occurred when a young girl was fatally kicked by a horse in the stables. It is said that her spirit roams the halls of the inn, described by

The Angel View Inn.

The Angel of the North.

witnesses as a figure with a void where her face should be. Additionally, staff members have reported sightings of a man who frequently appears near room 14, only to vanish upon being approached.

A current housekeeper shared an eerie experience while cleaning: after tidying the bathroom and making the bed, she heard a sound and discovered that all the taps in the bathroom had been turned on to full blast. In another incident in room 15, she had just made the bed and upon closing the door, noticed an indentation on the freshly made bed as if someone had lain there, complete with a head imprint on the pillow.

Guests staying in room 16 once reported being disturbed in the middle of the night by the sound of children running and laughing outside their door, despite no children being present in the hotel at the time.

Curiously, the *Angel of the North* itself is rumoured to be haunted by the ghost of a Second World War Nazi recruitment officer. Visitors have occasionally reported seeing this apparition, particularly at twilight, just as the last light of day fades.

Gibside

George Bowes, born in 1701, was the eldest child of Sir William Bowes, a Member of Parliament, and his wife Elizabeth. In 1713, the Bowes family acquired the Gibside estate, which boasted some of the most lucrative coal reserves in the north, significantly boosting their wealth.

Upon inheriting the estates in 1721, George Bowes embarked on the creation of an elaborate garden within the expansive 15 miles of woodland at Gibside. He personally designed the follies and walkways, including the notable Great Walk, which stretches over half a mile. Enhancements to the estate included a new kitchen block for the house, a stable block in 1746, and a banqueting house in 1752. In 1757, the Column of British Liberty was erected at the end of the Great Walk, featuring a 140-foot-tall statue crafted by Christopher Richardson.

In October 1724, Bowes married Eleanor Verney, who was just fourteen at the time, but tragically she passed away three months later. Rumours at the time suggested her death might have been due to Bowes's excessive sexual demands.

Bowes remained a widower for nineteen years before marrying Mary Gilbert in 1747. They had a daughter, Mary Eleanor Bowes, in 1748. She later married John Lyon, the 9th Earl of Strathmore and Kinghorne. As stipulated in George Bowes's will, John Lyon adopted the surname Bowes to inherit the estate, leading to the formation of the Bowes-Lyon family, which included the late Queen Mother, Elizabeth Bowes-Lyon.

George Bowes served as a Member of Parliament for County Durham and wielded significant influence, largely due to the coal wealth under his estates. He was instrumental in the founding of the Grand Alliance of coal owners in 1726.

In 1760, as work was underway on the orangery and chapel, intended as a family mausoleum, George Bowes passed away at Gibside. His son-in-law inherited the estates and Bowes was initially buried in Whickham, County Durham. The chapel was left unfinished for many years, eventually being completed in 1812, at which point Bowes's remains were reinterred there.

The marriage of Countess Mary Eleanor Bowes and the earl produced five children between 1768 and 1773, but it was marked by unhappiness. The earl succumbed to consumption in 1773. Mary Eleanor, not mourning his death, became involved with George Grey and became pregnant. She subsequently married another man, Andrew Robinson Shorey, who also took the Bowes name as per George Bowes's will.

Andrew proved to be an abusive husband, driven by greed. He frequently demanded money from his wife, subjected her to physical abuse, and even locked her in a cupboard within Gibside Hall. He sold her London residence and harvested trees from Gibside's woodlands to fund his lavish lifestyle. Mary Eleanor finally secured a divorce in 1789 and lived a quieter life in Hampshire until her death in 1800. Although she wished to be buried at Gibside's family mausoleum, she was interred at Westminster Abbey instead.

Gibside remained in the Bowes family until 1885, when the lineage ended with the childless death of George Bowes's great-grandson, John Bowes. The estate then fell into disuse, and Gibside Hall was abandoned. Many trees were cut down during the 1940s to support the war effort. The National Trust began restoration efforts in 1965, focusing on the dilapidated chapel and planning to revive the woodland's natural character. Gibside now hosts diverse wildlife, including the Red Kite, a bird species that had been nearly extinct in the British Isles less than thirty years ago.

There have been reports of a spectral figure moving towards the orangery, believed to be Mary Eleanor Bowes, whose spirit remains unsettled, having never been buried at her beloved Gibside. Additionally, the sound of a piano playing in Gibside Hall and the occasional scent of perfume have been experienced by visitors.

3
County Durham

Bowes Castle

Bowes Castle occupies the site of Lavatrae, a Roman fort spanning 4 acres, constructed during the Flavian era to safeguard a route through the Pennine mountains. This fortification, established in the first century, remained in use until the fourth century. In 1136, Alan the Red, Count of Brittany and owner of nearby Richmond Castle, erected Bowes Castle as a timber-and-earth structure. Throughout its history, the castle has witnessed significant conflict and bloodshed. In 1173, it endured a siege by Scottish forces under King William of Scotland, resulting in such severe damage that King Henry II commissioned its reconstruction in stone. This transformation into a formidable stone keep, surrounded by a rectangular moat, occurred between 1173 and 1187. The castle lacked curtain walls, suggesting its primary function was as a military outpost rather than a residential fortress.

Bowes Castle.

Between 1314 and 1322, Scottish raids ravaged northern England; by 1325 Bowes Castle lay in ruins. In the seventeenth century much of its stone was repurposed for local construction. The remaining ruins of the castle keep stand 53 feet tall, with parts of an interior staircase still accessible.

As Roman control in England waned by the late fourth century, the garrison at Lavatrae turned to plundering nearby villages, seizing valuable goods, especially gold. Enraged, the locals launched an attack on the fort, swiftly overcoming the Roman soldiers who were then killed. The Romans had hidden their loot before being defeated, and the treasure has never been found as none survived to reveal its location.

Legend has it that on the anniversary of this massacre, the spirits of the slain Roman soldiers appear at Bowes Castle, reenacting the burial of their stolen wealth. It's said that anyone witnessing these apparitions dies under mysterious circumstances before they can disclose the treasure's whereabouts. Visitors to the site often report feelings of unease and fear, along with a sensation of someone standing behind them, only to find no one present when they turn around.

Barnard Castle

Barnard Castle, perched on a cliff above the River Tees, shares its name with the surrounding town. The original fortification, a wooden structure, was established in the early twelfth century by Guy de Baliol, who had arrived in England with William the Conqueror's forces. The location was chosen for its defensive advantages, with the river providing natural protection on one side and steep cliffs on another.

Barnard Castle.

Around 1125, Guy's nephew, Bernard de Baliol, began reconstructing the castle in stone and expanded the site, adding a protective curtain wall. The castle and the burgeoning town around it came to be known as 'Bernard's Castle' after its builder. Bernard played a significant role in the Battle of the Standard in 1138, where English forces defeated a Scottish army led by King David I. Bernard passed away in 1155 and his son Guy inherited the estate, only to die in 1162. The property then passed to Bernard de Baliol II, who held it until 1199. With no direct male heirs, the castle then went to his cousin Eustace de Helicourt, who adopted the Baliol name upon inheriting the estate.

Hugh de Baliol, a staunch supporter of King John, defended the North from a rebellion led by the Northumbrian barons and supported by Scotland's Alexander I in 1216. During a siege of the castle that year, Eustace de Vesci, Alexander's brother-in-law, was killed by a crossbow bolt. After Hugh's death in 1228, his son, John de Baliol, took over. John married Devorguilla of Galloway in 1223, significantly enhancing the family's wealth and status. After her father's death in 1234, they became one of Britain's wealthiest families. John controversially imprisoned Devorguilla's illegitimate brother at Barnard Castle from 1235 to 1296 to secure his holdings.

Following John's death in 1269, Devorguilla had his heart embalmed and kept it with her in a silver casket. She established a Cistercian Abbey near Dumfries in 1273 in his memory. Devorguilla passed away in 1290 and was interred at the abbey with John's heart, leading the monks to name the site Sweetheart Abbey.

Their youngest son, John de Baliol II, ascended the Scottish throne in 1290 but was deposed in 1296, leading to his imprisonment in the Tower of London and the seizure of his English estates, including Barnard Castle, by the Crown. In 1307, King Edward II granted the castle to Guy de Beauchamp, Earl of Warwick. The Beauchamp family retained it until 1446, when Henry Beauchamp died without a male heir, passing the property to his sister Anne and her husband Richard Neville, known as 'the Kingmaker' for his role in the Wars of the Roses.

Richard Neville was killed in 1471, and his widow, Anne, lost control of the castle and estates to Richard, Duke of Gloucester, who became King Richard III in 1483. Richard III planned significant renovations for Barnard Castle but was killed in 1485 at the Battle of Bosworth Field before they could be carried out. Anne Neville regained control but transferred her estates to King Henry VII, who retained them for over a century, during which the castle fell into disrepair.

In 1536, a rebellion against the Protestant Reformation besieged Barnard Castle, leading its constable, Robert Bowes, to surrender due to internal dissent among his men. Later, during the 1569 Rising of the North, Sir George Bowes defended the castle against a 5,000-strong rebel force. Despite a prolonged siege and breaches in the castle's defences, Bowes eventually surrendered, delaying the rebels long enough for royal forces to regroup and quash the uprising.

In 1603, King James I granted the castle to Robert Carr, Earl of Somerset. It changed hands several times, eventually being sold to Sir Henry Vane in 1630. Vane removed much of Barnard Castle's stonework to renovate Raby Castle, furthering its decline. By the late eighteenth century, the castle was a ruin.

Barnard Castle from the River Tees.

In 1952, Lord Barnard of Raby transferred the estate to the Ministry of Works. Today, Barnard Castle is preserved by English Heritage.

The castle is said to be haunted by a woman known as Lady Ann Day, believed to have been murdered by being thrown from the castle wall into the river below in the sixteenth century. Witnesses often report seeing a spectral figure in white plummet from the heights, sometimes accompanied by a scream, but without ever hitting the water.

Visitors often report a sense of unease in the Round Tower, feeling as though they are being followed, a sensation that dissipates once they leave the area.

Additionally, the town has been a hotspot for UFO sightings. The most notable occurred on 6 June 1977 when a motorcyclist encountered a glowing, saucer-shaped object that seemed to drain power from his vehicle before quickly flying away.

Cauldron Snout

Cauldron Snout, a dramatic cascade on the upper River Tees, lies just downstream of the Cow Green Reservoir's dam. This majestic waterfall stretches over 600 feet in length and plunges 200 feet vertically, making it not only England's longest but also its highest waterfall. The furious torrent cascades down a series of dolerite ledges, creating a powerful and mesmerising spectacle.

Constructed between 1967 and 1971, the Cow Green Reservoir was designed to meet the growing water needs of the Teesside industrial area. Spanning 2 miles, it holds an impressive 40 million cubic meters of water. Despite its necessity, the reservoir faced

The Cow Green Reservoir's dam.

strong opposition from environmentalists concerned about the impact on Upper Teesdale's unique ecosystem, which includes ancient plant species like the Blue Gentian and Teesdale Violet. Thankfully, the reservoir's creation did not lead to the anticipated ecological catastrophe, and to protect the surrounding environment from future threats, the area was designated a National Nature Reserve.

Local legend speaks of a ghostly Victorian farmgirl, known as the Singing Lady, haunting Cauldron Snout. Though her real name remains unknown, her tragic story is well remembered. She was heartbroken after her affair with a married lead miner ended. Overwhelmed by despair, she leapt to her death at Cauldron Snout, her skull striking the jagged rocks before she drowned. Her spirit is said to drift across the waterfall's surface on moonlit nights, often described as either weeping or singing. However, her lament is typically overshadowed by the roaring waters of Cauldron Snout.

While the Cow Green Reservoir did not severely impact local wildlife, it is believed to have destroyed the valley where Peg Powler, a mythical hag, was said to dwell. This legend, originating in the eighteenth century, was likely invented by concerned parents to explain the mysterious disappearances of children near the River Tees. According to the tale, Peg Powler, a green-skinned witch, would emerge from the river to snatch children who ventured too close to the edge, dragging them under to her lair to devour them. The green froth seen on the water's surface was dubbed Peg Powler's Suds, a warning of her presence.

The Cauldron Snout waterfall.

Though many regard Peg Powler as a mere myth, there have been several reported sightings of a creature resembling her:

- In 1754, John Tallentire noted in his diary an encounter with 'a creature of greenish hue and utter terror' in the River Tees.
- In 1767, Isaac Pennington documented in his ship's log 'a strange entity observed from the port bow. It frightened all the fish and half my crew'.
- In 1864, Emily Jackson wrote in her diary about a bizarre experience, describing an attack by a hag-like fish creature emerging from the Tees, leading her to believe she might be losing her sanity.

Durham Castle

Durham Castle and the stunning cathedral are prominent symbols of the city and county of Durham. The castle, constructed in 1072 by order of William the Conqueror during his campaign to secure the North, was a motte-and-bailey structure. Supervised by Waltheof, Earl of Northumberland, it was strategically placed to protect the peninsula formed by the River Wear.

The previous year, William Walcher had been appointed Bishop of Durham, with the castle serving as his residence. As bishop, Walcher held royal authority in the region. After Waltheof's execution in 1075, Walcher also became earl, becoming the first Prince

Below and opposite: Durham Castle.

61

Bishop. He established a hall on the site of what is now the great hall and added the undercroft and Norman chapel. Despite his good nature, Walcher's ineffective leadership led to his assassination in Gateshead in 1081.

The bishops' domain, known as the County Palatine of Durham, acted as a buffer zone against Scotland. The Prince Bishops wielded king-like powers, including legislative authority, military command, and the right to mint coins. In 1300, Prince Bishop Antony Bek famously stated, 'There are two kings in England: the King of England and the Bishop of Durham.' Bek built the present great hall in 1284, which Bishop Thomas Hatfield expanded in 1350, making it the largest great hall in Britain until later alterations by Bishop Richard Foxe.

Henry VIII significantly curtailed the power of the Prince Bishops in 1536, a reduction that continued through the English Civil War. During the Tudor era, Bishop Cuthbert Tunstall added a chapel and the galleries that now bear his name.

Durham Castle suffered during the Civil War, and when England became a Commonwealth in 1649, Oliver Cromwell seized it, later selling it to the Lord Mayor of London. The castle was returned to the bishops with the Restoration in 1660, and subsequent renovations were made by bishops John Cosin and Nathaniel Crewe, including the construction of the Black Staircase.

In 1837, the castle was donated to the newly established University of Durham by Bishop William Van Mildert. The ruined keep was restored in 1840 by architect Anthony Salvin, matching the original Norman design to house students. In the late 1920s, emergency repairs were made to prevent the north-west corner from collapsing into the River Wear. The castle remains under Durham University's care.

One highlight of a visit to Durham Castle is the Black Staircase, a 57-foot-tall dark oak marvel, noted for its historical significance and haunting tales. A spectral woman has been seen ascending these stairs since the seventeenth century, although her identity remains unknown; legends erroneously suggest she was a bishop's wife who met a tragic end.

A lesser-known ghost tale involves Frederick Copeman, one of the first students at the newly established University of Durham in the early 1800s, when the castle served as University College. Frederick resided in the highest room atop the Black Staircase, known among students as the 'Crow's Nest'. As his final exams approached, he grew increasingly anxious. After taking the exams, he nervously awaited the results, which were posted outside the university library on Palace Green, as is still done today.

The results were listed with first-class degrees at the top, followed by other classifications. If a name was missing, it indicated a complete failure.

Frederick, unable to find his name on the list, returned to his room in despair. In a state of agitation, he suddenly bolted from his room, rushed down the Black Staircase, and, ignoring everyone around him, sprinted across Palace Green to the cathedral. There, he ascended the tower and tragically leapt to his death.

Unlike many ghost stories, Frederick Copeman's apparition is not seen but heard. His ghostly footsteps can be heard pacing the floor of the Crow's Nest, reliving his final,

University results were posted on Palace Green, as they still are today.

tortured moments. The sound of a door slamming open and his hurried steps down the wooden stairs follows.

Since Copeman's tragic death, the cathedral tower has been kept locked whenever degree results are posted to prevent similar incidents. The Crow's Nest is no longer used as a student room and now serves only as a storage space. The twist in Frederick's story is that a later examination of the results revealed that a list pinned above had accidentally obscured his name. He had actually earned a first-class degree.

Crook Hall

Crook Hall is a historical manor that dates back to 1286, originally established on land once part of Sydgate Manor. The property was initially owned by Gilbert de Aikes, who transferred it to Aimery, the son of the Archdeacon of Durham, in 1217. The estate later came into the possession of Peter de Croke in the early fourteenth century, giving the hall its name, which persisted through the centuries, as seen in 1749 maps of Durham labelled as Croke Hall.

By 1415, the hall was under the ownership of Thomas Billingham and remained within his family until 1657, when it was sold to the Mickleton family. The Mickletons undertook

Crook Hall.

significant restoration work in 1671. Upon the death of James Mickleton, the grandson of the original Mickleton purchaser, the hall was sold in 1721 to settle his debts.

Over time, various owners continued to enhance Crook Hall, resulting in a remarkable Grade I listed building showcasing three distinct architectural periods: the original Medieval Hall, Jacobean modifications by the Mickletons, and an eighteenth-century Georgian addition by the Hopper family. The hall's gardens, praised by Alan Titchmarsh as a 'tapestry of colourful blooms,' draw visitors from across the country. Despite its elegance, Crook Hall is shrouded in mystery, with tales of hidden passageways and the legendary White Lady ghost of County Durham.

The White Lady's true identity remains a mystery, though some speculate she may be a niece of Cuthbert Billingham, a former owner. This apparition is often seen descending an old wooden staircase in the manor's oldest section, which mysteriously ends at the ceiling. Her presence is also sensed in the Jacobean Room, adding to the hall's enigmatic allure.

Lumley Castle

Lumley Castle owes its origins to Sir Ralph Lumley, a prominent figure in northern England. A knight since 1385, Sir Ralph gained recognition for his bravery during the defence of Berwick-upon-Tweed against the Scots. In 1388, he led the charge at the Battle of Otterburn, where despite his valour, he was captured and held in Scotland. The following year, he regained his freedom and returned to his family manor. With the approval of

Above, below and overleaf: Lumley Castle exterior and interior.

the Bishop of Durham, he began transforming the manor into a fortified castle, a project completed in 1398.

In January 1400, Sir Ralph and his son, Thomas, became involved in a plot to overthrow King Henry IV and reinstate Richard II. The plan, which involved attacking the king at a Windsor Castle tournament, was foiled when Edward, Earl of Rutland, revealed the conspiracy. As a result, Sir Ralph and Thomas were executed, and their titles and lands were seized. The Earl of Somerset controlled the estate until his death in 1421, after which Lumley Castle was returned to Sir Ralph's grandson, Thomas Lumley.

The castle has remained in the Lumley family ever since. In 1976, it was leased to 'No Ordinary Hotels' and transformed into a luxurious fifty-nine-room hotel, complete with medieval decor and period-dressed staff. The castle's atmosphere is enhanced by its historical architecture and dark corridors, making it a popular destination for both tourists and ghost hunters.

Among the castle's legends is the story of Lily of Lumley, Sir Ralph's wife. The couple were followers of the Lollard movement, a pre-Reformation group influenced by John Wycliffe. During Sir Ralph's absence in Berwick-upon-Tweed, two priests attempted to convert Lady Lumley back to Catholicism. When she refused, they murdered her, disposing of her body in a well and spreading a false story of her departure to a convent, where she supposedly died. Depending on the version of the tale, Sir Ralph either

The well where Lily of Lumley's body was disposed.

believed the priests or executed them for their actions. The well remains visible, now covered by glass, and it is said that Lily's ghost still roams the castle, her footsteps echoing through the halls.

Lumley Castle gained international attention in June 2005 when the Australian cricket team reported eerie experiences during their stay. Shane Watson, unnerved, shared a room with a teammate, while media officer Belinda Denenett claimed to have seen ghostly figures. This incident wasn't unique; in 2000, members of the West Indies cricket team, including captain Jimmy Adams, left the castle in the middle of the night due to similar fears.

Haunting Breaks, a paranormal investigation company, has documented several ghostly encounters at the castle. During a January 2006 investigation, a guest saw a spectral figure of a little girl in nineteenth-century attire. In room 63, unexplained noises were reported, and photographs showed numerous orbs, suggesting paranormal activity. During a dinner vigil, guests experienced headaches and witnessed strange lights and movements. One sceptic even felt a whisper in his ear, and a shadow was seen moving toward a chair, where an orb was subsequently photographed.

The surrounding area also has a rich history of paranormal phenomena. A headless horseman is said to ride from Lumley Castle to Finchale Priory, particularly on stormy nights. Battle sounds, including clashing swords and dying cries, have been heard in the castle grounds and nearby woods.

One of County Durham's most famous ghost stories involves the murder of Anne Walker in 1630 at Lumley Mill. John Grahame, a miller, encountered her bloodied ghost, who revealed her murder at the hands of Mark Sharpe, under the orders of her uncle, John Walker. Despite initial disbelief, Grahame eventually reported the crime after multiple encounters. The authorities found Anne's body and the murder weapon as described, leading to the arrest and execution of Walker and Sharpe. The motive appeared to be to conceal that Walker was the father of Anne's unborn child. The case concluded with their hanging, although they maintained their innocence until the end.

The North of England Lead Mining Museum

Park Level Mine, established in 1853, was a significant site for extracting lead ore in Killhope. For over fifty years, the North Pennines resounded with the activities of the lead mining industry until the mine closed in 1910.

Miners faced hazardous working conditions, with minimal protection against accidents like falling debris or explosions. While there were only three documented fatalities directly in Park Level, many more succumbed to Anthracosis, a lung disease caused by dust inhalation, colloquially known among the miners as 'the Black Spit'. This affliction was often a death sentence, marked by a tell-tale dark substance in their spit.

The North of England Lead Mining Museum.

Park Level Mine.

Children, some as young as seven, were employed on the Washing Floor, where they endured long hours for a meagre wage of fourpence a day, separating lead ore from waste materials. This practice ended in the late 1870s with the construction of Park Level Mill, which utilised a 12-meter-diameter waterwheel to automate the crushing and separation of lead ore.

The mine briefly reopened during the First World War to supply lead to the North East. In 1980, restoration efforts began at Killhope, transforming it into the North East Lead Mining Museum, the most complete of its kind in Britain. The iconic Killhope Wheel, once among many in the region, remains the sole survivor, and visitors can explore both the surface grounds and the underground mine.

Beliefs about hauntings at the mine, grounds, and nearby woodland date back to its operational days. Miners spoke of 'Tommyknockers,' ghostly figures that roamed Killhope. While some of these spirits were harmless, others were believed to be malicious, intent on spreading fear and disruption.

In recent years, museum staff and visitors have reported eerie occurrences. Footsteps and whispers have been heard in the mine shop, even when only one staff member was

The Killhope Wheel.

The mine shop.

present. Tourists often felt an unseen presence during mine tours, with multiple accounts corroborating these sensations. A dark, shadowy figure has occasionally been spotted in the torchlight, believed to be the ghost of Thomas Heslop, who met a gruesome end on 18 September 1879 when he was caught in a waterwheel and dismembered. Miners who entered Park Level that day were horrified to find the water tinged with blood and body parts.

An unusual phenomenon occurs in the miner's cottage exhibit, set up to replicate a period living space, complete with mannequins. A draughts board in the room, used to illustrate the miners' leisure activities, has reportedly had its pieces mysteriously rearranged overnight, despite the museum being locked and unattended.

There is also a local legend of a woman who ventured into the woods one night searching for her husband and was never seen again. The origins and timeframe of this tale are unclear, but her anguished screams are said to echo through the wooded area on dark nights.

Beamish Hall
In 1268, Philip de la Leigh provided Sir Bertram Monboucher and his daughter with the Tanfield Manor as a marriage gift. Sir Bertram then established the first manor for his family on the current site of Beamish Hall. The Monboucher family inhabited Beamish Manor for five generations, concluding in 1400 with the last family member's death.

Above and below: Beamish Hall.

During the Middle Ages, the estate passed through the hands of various regional nobles, including the prominent Northumbrian Percy family. However, in 1569, the manor was confiscated by the Crown following Thomas Percy, 7th Earl of Northumberland's involvement in the Rising of the North. After the failed uprising, Thomas fled to Scotland but was captured by the Earl of Morton. He spent three years imprisoned before being handed over to Queen Elizabeth I, who had him executed in York on 22 August 1572.

The oldest section of the existing hall was constructed around 1620 by the Wray family as a new manor house.

In 1682, Timothy Davison, a governor of the Merchants Company of Newcastle, acquired the estate. His son William lived at the hall with his second wife, Dulcibella. Their youngest daughter, Mary, married Sir Robert Eden, 3rd Baronet of Windlestone Hall, in 1739.

The Edens erected the current three-storey hall in the mid-eighteenth century, replacing the older structure.

Catherine Eden married Robert Eden Duncombe Shafto of Whitworth Hall in 1803. Their grandson, Revd Slingsby Duncombe Shafto, inherited the estate in 1904 and added Eden to his name.

Robert Shafto followed, but his death in 1949 left the estate with substantial inheritance taxes, forcing his heir, another Robert, to sell and relocate to Bavington Hall.

The National Coal Board leased Beamish Hall in 1954, using it as a regional office. In 1966, Durham County Council acquired the hall, subletting parts of it to Beamish Museum and using other sections as a music college. The hall remained vacant for several years until its renovation and reopening as Beamish Hall Country House Hotel in August 2000.

The most famous member of the Shafto family associated with the estate was 'Bonnie' Bobby Shafto. Although his primary residence was Whitworth Hall, he spent considerable time at Beamish. During the late 1770s, while staying at Beamish Hall, Bobby met and fell in love with Bridget Bellasyse of Brancepeth. They were expected to marry, but Bobby wanted to explore the world first. They agreed that he would travel and return to marry Bridget.

As Bobby departed, Bridget tearfully bade him farewell. Despite the distance, she held onto hope for his return. Legend has it that Bridget authored the well-known northern rhyme that has kept Bobby's name alive:

Bobby Shafto's gone to sea,
Silver buckles at his knee;
He'll come back and marry me,
Bonny Bobby Shafto.

Bobby Shafto's bright and fair,
Combing down his yellow hair,
He's my ain for ever mair,
Bonny Bobby Shafto.

Bobby Shafto's tall and slim,
He's always dressed so neat and trim,
The lassies they all keek at him,
Bonny Bobby Shafto.

Bobby Shafto's gett'n a bairn,
For to dandle on his airm,
On his airm and on his knee,
Bobby Shafto loves me.

Bobby returned to the region but ended up marrying Anne Duncombe instead, devastating Bridget. Desperate to see Bobby, Bridget went to Beamish Hall, sneaking inside. Spotted by a servant, she panicked and hid in a chest, accidentally locking herself in. Tragically, Bridget died inside, her fate unknown until her mummified remains were discovered nearly thirty years later, along with a wedding dress.

Today, Bridget, known as the Grey Lady, is said to haunt Beamish Hall. Her ghostly presence is reported in the lower parts of the hall, where she met her tragic end, and she's also seen gazing sadly out of the Bridal Suite window.

The reception of Beamish Hall.

The Grey Lady isn't the only apparition at Beamish Hall. Some staff have reported unsettling feelings in certain rooms, particularly Shafto Hall, where they've heard footsteps with no apparent source.

In the Eden Bar, sightings of an elderly woman in Edwardian attire, complete with a pink hat, have been reported. The Eden Room is supposedly haunted by a man dressed in Victorian clothes, often seen staring out the window.

A woman, possibly named Charlotte, has been seen in the reception area, and in the attic rooms lights reportedly spin on their own, attributed to the spirits of two young children believed to play there.

Not all hauntings are ancient, however. In 2005, a medium sensed two recent spirits: one of a woman who married at Beamish Hall in the early 2000s and another of a young man who died in a car crash after working at the hall.

For those seeking the spectral inhabitants of Beamish Hall, a visit to nearby Beamishburn is highly recommended. A haunting legend from the seventeenth century tells the tragic story of a young woman, often called Mary, though some versions refer to her as Marie. Described as polite, family oriented, and determined to maintain her purity until marriage, she was a petite beauty with long red hair who attracted much attention from local men. However, she always courteously declined their advances.

One evening, three men were drinking in a local tavern and began discussing Mary. Frustrated by their failed attempts to win her affection, they drank heavily and decided to confront her directly. They went to her house late at night, where she answered the door in her nightgown, alone since her parents were away. They asked to enter, and when she refused, they forced their way in. Panicking, Mary pleaded with them to leave, but they mocked her and pushed her into a chair, ignoring her cries for help.

That night, the men assaulted Mary. Once the initial horror passed, they realised the gravity of their actions, knowing that she could identify them. To silence her forever, two men restrained her while the third cut out her tongue, preventing her from speaking. Fearing she might still expose them, they brutally mutilated her hands with a mallet, rendering them useless, and then gouged out her eyes to ensure she could never see them again. Believing they had covered their tracks, they left her in a state of utter despair and agony.

Mary's parents returned to find her barely conscious. They did their best to care for her, but the trauma and mutilation left her deeply scarred. She loved her parents, but the injustice of what happened weighed heavily on her, making her feel life was no longer bearable.

Using her remaining sense of hearing, Mary found her way to the fast-flowing waters of Beamishburn, where she ended her life. Her lifeless body was discovered the next day.

After nightfall, some visitors to the bridge over Beamishburn have reported seeing a ghostly figure of a young woman with long red hair hovering above the water, holding her arms out as if to show the damage done to her hands. Others have claimed to hear a chilling scream, sometimes seeming to emanate from beneath the water.

Beamishburn.

4
Teesside

Dorman Museum

Situated on the edge of Albert Park in Linthorpe, Middlesbrough, the Dorman Museum stands as a testament to the rich history and evolving culture of the region. Opened in 1904, the museum was established by Sir Arthur Dorman in memory of his son, Lieutenant George Lockwood Dorman, who fell during the Second Boer War. Designed by the architectural firm J. M. Bottomley, Son and Welford, the building itself is a striking example of Edwardian baroque architecture, featuring smooth red brick with terracotta dressings, Welsh slate roofs, and a distinctive copper-clad dome.

The museum's initial focus was on natural sciences, but over the years, its scope has expanded significantly. It now houses an impressive array of exhibits, including the Linthorpe Art Pottery collection, Victorian taxidermy, and a treasure trove of local and international artifacts. The collections are as diverse as they are intriguing, ranging from ancient Bronze Age implements to twentieth-century women's fashion, and from botanical specimens to an extensive zoological collection. Highlights include the Linthorpe Art Pottery gallery, which celebrates the works of Christopher Dresser and the pottery's influential role in decorative arts, and the Nelson Room, which preserves the Victorian collection of mounted birds and eggs.

Despite its vibrant array of exhibits, the Dorman Museum is also known for its eerie reputation. Staff and visitors alike have reported strange occurrences within its walls,

Below and overleaf: The Dorman Museum.

Above and below: Footsteps and coughing is heard among the museum's exhibits.

particularly in a specific corridor where footsteps and unexplained coughing have been heard. This corridor is believed to be where Dr Frank Elgee, a former curator, once had his office.

Dr Elgee, an archaeologist, naturalist, and geologist, was instrumental in the museum's early development. He began his association with the museum as an assistant curator and was later appointed curator in 1923. Known for his dedication and contributions, despite his own health struggles, Elgee's passion for the museum and its collections was evident throughout his tenure. After his death in 1944, reports of haunting activities began to surface. Witnesses claim that the sounds of footsteps and occasional coughing echo through the corridor where his office was located, suggesting that Dr Elgee's spirit may still be overseeing the institution he cherished.

Seaton Hotel

Located in the charming seaside resort of Seaton Carew, the Seaton Hotel, originally known as the Ship Inn, has a history that stretches back over two centuries. Established in 1787, the Ship Inn was advertised for lease with adjacent fields and houses, serving as a popular spot for visitors drawn to Seaton Carew's attractive sea-bathing opportunities. The inn's picturesque location, offering fine views of Tees Bay and the Cleveland coast, made it a favoured retreat for those seeking relaxation and scenic beauty.

By 1791, the Ship Inn was described as a well-frequented establishment, particularly during the bustling bathing season. Despite its popularity, the property struggled to attract a new tenant, prompting a significant change in ownership. In 1792, George Pearson, a wealthy gentleman from Durham, purchased the inn and its surrounding properties. Pearson, who already owned considerable property in Seaton Carew, demolished the old inn and constructed a coach house and three adjoining houses to cater to the affluent Quakers who frequented the village during the summer months.

The new building, initially named the New Inn, continued to evolve. By the early nineteenth century, specifically between 1800 and 1804, it was renamed the Seaton Hotel. Despite this change, some references still referred to the property as the Ship Inn until 1808. The Seaton Hotel's history is deeply interwoven with the development of Seaton Carew as a popular coastal resort.

Today, the Seaton Hotel is known not only for its historical significance but also for its ghostly residents. Situated along the picturesque North Sea coast, the building has become the centre of local folklore and paranormal intrigue. Bar staff and patrons have reported various unsettling experiences, particularly concerning unexplained phenomena.

The Seaton Hotel.

One of the most intriguing accounts involves mysterious wet, sandy footprints. On one occasion, a member of staff arrived to open the pub for the day and found these footprints leading through the hallway, originating from one locked door and ending at another. The wet, sandy marks left a trail across the floor, perplexing both staff and visitors, as the source of the footprints remained a mystery.

Camerons Brewery

Established in Hartlepool for over 150 years, Camerons Brewery has long been a cornerstone of the north-east of England's brewing heritage. Founded by John William Cameron in 1865, this venerable establishment has evolved into the largest independent brewer in the region.

The brewery's origins trace back to 1852, when William Waldon acquired the Lion Brewery, capitalising on the site's pure artesian well. This well, still in use today, has been a vital part of the brewery's identity. After Waldon's death in 1854, his widow handed over the operation to John William Cameron in 1865. Cameron's vision transformed the brewery, leading to substantial expansions including the construction of the current Lion Brewery building in 1892. Under his leadership, Camerons expanded aggressively, acquiring numerous breweries and public houses across the North East.

The early twentieth century saw Camerons at its zenith, owning a significant portion of Hartlepool's public houses and establishing a formidable reputation. By the 1950s, the company had introduced its flagship Strongarm bitter, which would become a national favourite, boasting over a billion pints in production by 2000.

However, the latter half of the twentieth century brought challenges. Following a series of ownership changes — from Ellerman Lines to the Barclay Brothers, Brent Walker, and finally Wolverhampton & Dudley — the brewery faced fluctuating fortunes. Each new owner brought different strategies, with varying degrees of success and controversy. Despite these trials, Camerons adapted and evolved, eventually regaining some independence under Castle Eden Brewery in 2002.

Camerons Brewery.

Amid its rich industrial history, Camerons Brewery has also garnered a reputation for the paranormal. The brewery's location on Silver Street, now encapsulated within its walls, carries echoes of its past. Visitors often recount eerie experiences, such as hearing the ghostly sounds of horses that once delivered goods through this very entrance. The ghosts of former employees and patrons are said to linger, adding an otherworldly dimension to the brewery's storied past.

Today, Camerons Brewery continues to thrive, with a capacity of over 1.5 million hectolitres per annum and a portfolio that includes contract brewing for major brands like Heineken. The Lion Brewery remains a testament to its historical grandeur, featuring opulent Italian marble and state-of-the-art brewing facilities. The brewery's Heritage Centre, located at the former Stranton Arms, offers a fascinating glimpse into the brewing process and the company's history.

Visitors can explore the brewery through guided tours that offer a behind-the-scenes look at the production of Camerons beers, including the iconic Strongarm. The tours conclude in a fully licensed bar, where guests can enjoy a pint of the brewery's celebrated ales while soaking in the atmosphere of this historic site.

Middlesbrough's Central Library

In the heart of Middlesbrough, on Centre Square, stands the magnificent Central Library – an architectural gem with a rich history and a reputation for ghostly encounters. Officially opened on 8 May 1912, this Grade II listed building, often referred to as the Carnegie Library, was made possible through the generous donation of £15,000 by Scottish-American philanthropist Andrew Carnegie. It was constructed on land donated by Sir Hugh Bell and Alderman Amos Hinton JP.

Designed by architects S. B. Russell and T. E. Cooper, the library showcases a classical design that reflects the prosperity of Middlesbrough in the early twentieth century. The structure is noted for its impressive use of materials, including Pately Bridgestone, Leicestershire red-facing bricks, and Precely green slates. Inside, visitors are greeted by the grandeur of marble staircases and oak panelling in the reference rooms, all complemented by decorative fibrous plaster ceilings.

Central Library was Middlesbrough's first purpose-built public library, offering a range of facilities from lending sections to dedicated spaces for boys, girls, ladies, and a central newsroom. Over the years, the library has evolved, with significant updates including the renewal of the lending section's floor in 1965.

Beyond its architectural splendour, the Central Library plays a crucial role in the community. It provides access to a wealth of library services, including reference materials for local and family history, free internet and Wi-Fi, space for community meetings, and facilities for early years and youth activities. The library also hosts numerous cultural events throughout the year, making it a vibrant hub for the town's social and educational life.

As the library approaches its 120th anniversary, it has garnered a reputation not just for its historical and cultural contributions but also for its ghostly residents. Staff and visitors alike have reported unsettling encounters, particularly on the top floor, which has come to be known as 'The Ghost Room'.

Middlesbrough's Central Library.

Accounts from female staff members include chilling experiences of having their hair touched or feeling a phantom hand brushing against them. These eerie sensations have been accompanied by reported sightings of a ghostly figure captured in a photograph by a staff member. The image, although not widely available online, is said to depict a spectral presence looming in the twilight.

The library's ghostly reputation was further cemented by a 2008 BBC article detailing a ghost hunt conducted by children in the library. During this event, aimed at encouraging young people to engage with the library, the children took several photographs. It wasn't until later that they discovered what appeared to be a ghostly figure in one of the images. Librarians have since admitted their curiosity about the nightly activities of whatever — or whoever — might be perusing the shelves after hours.

Acklam Hall

Acklam Hall, an illustrious Grade I listed building in Middlesbrough's Acklam suburb, boasts a rich history that spans over three centuries. The hall's origins trace back to the early seventeenth century, when Sir Francis Boynton owned the estate. However, it was not until 1637 that William Hustler, a wealthy cloth merchant from Bridlington, acquired Acklam Hall and its extensive lands from the Boynton family. Hustler's ambition to establish a country estate close to the River Tees for his trading ventures marked the beginning of Acklam Hall's long association with the Hustler family.

William Hustler's grandson, also named William Hustler, was instrumental in the hall's transformation. Between 1680 and 1683, he constructed Acklam Hall in a fashionable style

that reflected contemporary Dutch influences. This two-storey mansion became the seat of the Hustler family for over 200 years, showcasing a blend of elegance and progressive architectural design.

In 1845, Thomas Hustler, who was actively involved in the development of Middlesbrough, undertook significant alterations to the hall. The building continued to evolve with additional enhancements made by the renowned architect Walter Brierley in the early twentieth century. These modifications preserved Acklam Hall's historical grandeur while adapting it for modern use.

The hall's journey continued through the twentieth century as it transitioned from a family residence to a public institution. Middlesbrough Corporation acquired the property in 1928 and Acklam Hall was subsequently repurposed into a school in 1935. It served as Acklam Hall School and later as a comprehensive school before becoming part of Middlesbrough College.

In 2016, after an extensive restoration, Acklam Hall reopened to the public as a premier venue for weddings, corporate events, and dining, solidifying its place as Middlesbrough's only Grade I listed building.

Acklam Hall's historical significance is matched by its reputation for the supernatural. Among its most enduring ghostly legends is the tale of the 'Grey Lady,' believed to be the spirit of Charlotte Hustler, who died during childbirth in 1800. Charlotte's apparition is said to appear on one of the hall's staircases, where she is reported to stand before fading away.

The hall's reputation for paranormal activity is bolstered by various accounts from those who have experienced unexplained phenomena. In 1967, a caretaker reported that his dog would refuse to enter the hall's library, seemingly disturbed by something unseen.

Below and overleaf: Acklam Hall.

85

Acklam Hall.

Additionally, in 1997, a workman claimed to have seen a boy dressed in ragged Victorian clothing in the cellar. The boy was seen walking into a side room, but when the workman followed the boy had vanished without a trace.

The Swatters Carr

The Swatters Carr, a prominent JD Wetherspoons pub in Middlesbrough, is more than just a popular drinking spot; it is a building steeped in history and rumoured to be haunted by its spectral past. Situated on Victoria Road, the three-storey structure has served as a public house for over a century, reflecting the rich and varied history of Middlesbrough.

Originally known as the Empire Hotel, the building first appears in the 1891 census as the Swatters Carr Hotel Public House. This name pays homage to a farmhouse called Swatters (or Swathers) Carr, first recorded on a map in 1618, which once stood in the vicinity. The farmhouse was replaced in 1903 by the Grand Opera House, a venue that attracted notable performers such as Charlie Chaplin and Gracie Fields.

By 1930, the Grand Opera House was converted into the Gaumont cinema, which thrived until it was replaced by offices in 1964. The cinema site and the pub site are linked by Ashburton Terrace, a Victorian street with three original façades still intact. Despite these changes, the pub has retained a connection to its historical roots through its name and its location.

In 2011, the building reopened as the Swatters Carr under the ownership of JD Wetherspoon. Prior to this, it had been known by several names, including The Tavern,

The Swatters Carr.

The House, and The Hogshead, but it was most famously called The Empire. The decision to revert to the Swatters Carr name honours its historical identity and reflects the pub's deep ties to the local community.

Beyond its historical significance, the Swatters Carr is reputed to be haunted. Staff and visitors have reported eerie phenomena that suggest the presence of a restless spirit. Loud bangs and crashes are frequently heard from the upper floors, even when they are empty.

Inside the busy – and haunted – Wetherspoons pub.

The sounds are often described as disruptive and unsettling, echoing through the building's corridors.

Moreover, staff members have experienced disquieting encounters, including hearing unexplained growls and snarling noises when alone on the upper floors. These spectral sounds have contributed to the pub's reputation as one of Middlesbrough's haunted locales, adding an atmospheric and spine-tingling dimension to its historical charm.

Wynyard Woodland Park

Wynyard Woodland Park, formerly known as the Castle Eden Walkway, is a captivating expanse that stretches over 2 miles from Thorpe Thewles to Tilery Wood near Wynyard. Originally a bustling railway line used for transporting freight to the ports along the River Tees, this park now offers a picturesque array of walking and cycling trails. The main cycle route, following the old Castle Eden branch railway established in 1880, is a key feature of National Cycle Network Route 1, offering scenic journeys through the heart of the park and connecting south to Stockton and north into County Durham.

The park encompasses over 10 miles of paths, surrounded by dark, dense woodland. Highlights include the remnants of Thorpe Thewles station, including its platform and coal drops, and the tranquil Brierley and Tilery Woods. Thorpe Wood, with its ancient oak, ash, and wych elm trees, provides a serene backdrop, while Stoney Field features the unique *Celestial Kitchen* sculpture. Pickards Meadow is particularly stunning in late spring and early summer. For families, the big adventure playground offers endless fun, and the Station House Tea Room provides a perfect spot to unwind.

Beyond its scenic appeal, Wynyard Woodland Park is shrouded in intriguing tales of the supernatural. The park's former railway station, now the Visitor Centre, is rumoured to be haunted by the spirit of a long-gone stationmaster. Legend has it that this stationmaster met a grim fate at the hands of migrant workers, and his restless spirit is said to roam the centre, possibly still seeking retribution.

An old railway carriage in Wynyard Woodland Park.

The old railway station.

In addition to this spectral presence, visitors have reported encounters with a large, shadowy feline, rumoured to be a black beast prowling the area. However, many locals believe it's wise to be cautious of the unseen forces that might linger in the park.

The park also hosts an array of historical and educational exhibits. The old railway station now houses a Visitor Centre with displays on archaeology, woodland history, and local wildlife. It features interactive experiences such as weaving and woodturning, alongside a planetarium and observatory for exploring the cosmos, even on cloudy days.

Preston Hall Museum

Preston Hall, surrounded by 100 acres of lush parkland known as Preston Park, is nestled in the wooded Tees Valley near Stockton. The land's earliest mention dates back to 1183 in The Boldon Buke, Durham's counterpart to the Domesday Book, when it was merely farmland.

By 1515, a stately manor had been established on the site, owned by William Sayer. This estate was later confiscated by the Crown due to the involvement of Lawrence Sayer, a Royalist during the English Civil War.

In 1673, George Witham acquired the manor, renaming it Witham Hall. The estate changed hands in 1722 when William Witham sold it to Sir John Eden of Windlestone Hall. By 1812, it had passed to David Burton Fowler, who initiated the transformation of Preston Hall into its present form in 1825.

Above and below: Preston Hall Museum.

The hall came into the possession of local shipbuilder Robert Ropner in 1882, who retained it until after the Second World War. At that point, there were plans to convert Preston Park into a shopping centre. However, Stockton Borough Council intervened, purchasing the estate, and in 1953 Preston Hall opened to the public as a museum and gallery.

Since its opening, the museum has been the site of numerous unusual events reported by both visitors and staff.

A phantom highwayman has been observed near the museum's entrance. It is speculated that he might have been associated with the nearby Stockton and Darlington railway, though details about his identity and demise remain unclear. Psychic investigations have not yielded any information about this spectral figure.

The most renowned ghost at Preston Hall is the Grey Lady. Often seen in the brown corridor adjacent to the Period Rooms, visitors have reported intense feelings of sadness in this area, sometimes leading to tears. According to one account, the Grey Lady was a young woman who lived at the hall, became pregnant by the groundskeeper, and lost the child. Another story suggests that a young woman from a local peasant family, forbidden by her suitor's aristocratic family, took her own life in Preston Park out of despair. The true origins and identity of the Grey Lady remain a mystery.

In what is known as the Dungeon — an old wine cellar — a ghostly dog has been spotted walking through walls. This area is often described by visitors as unsettling, with many experiencing intense fear and unease.

Additionally, a spectral figure resembling a cleaner has been observed polishing the museum's display cases, and the spirit of a First World War oldier has been seen on the stairs leading to the armoury.

The Brown Corridor.

Preston Hall Museum stands in 110 acres of parkland and woodland.

About the Author

Rob Kirkup was born in Ashington, Northumberland, and has lived in the North East all his life. He developed a keen interest in myths, legends, the paranormal, and all things considered supernatural or otherworldly from an early age, amassing a large collection of books and newspaper cuttings on the subject, and in particular tales based in his native north-east of England.

Rob had his first book published in 2008 and has since written a number of books focussing on different aspects of the history of Northumberland, Tyne and Wear, County Durham, Cumbria, York, and Edinburgh.

In 2022 Rob started his podcast *How Haunted?* with each episode looking at the history and ghost stories of one of the most haunted locations in the world. It has proven very popular and is available everywhere you would usually find your podcasts, including Spotify, Apple Podcasts, Google Podcasts, and Alexa-enabled devices.

Above left: The author on Inner Farne with a very angry Arctic tern sat on his head.

Also From Amberley

PARANORMAL NORTHUMBERLAND
ROB KIRKUP

A spine-chilling collection of stories of hauntings, apparitions and paranormal activity from Northumberland.

Available to purchase from amberley-books.com or by calling (+44) 1453 847800.

ISBN: 9781445698984

PARANORMAL MIDDLESBROUGH AND TEESSIDE

STEVE WATSON

A fabulous collection of ghostly hauntings in Middlesbrough and Teesside. These tales of haunted places, supernatural happenings and weird phenomena will delight ghost hunters.

Available to purchase from amberley-books.com
or by calling (+44) 1453 847800.

ISBN: 9781398114517